A YEAR OF
DAILY JOY

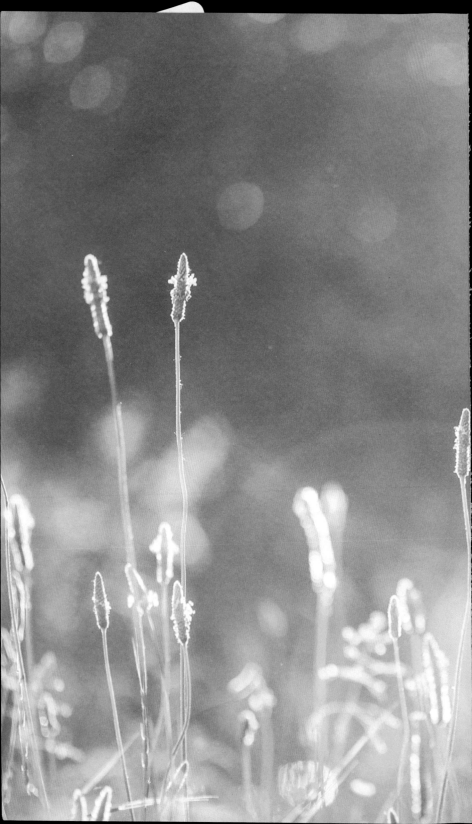

A YEAR OF
DAILY JOY

*A Guided Journal to Creating
Happiness Every Day*

Jennifer Louden

NATIONAL GEOGRAPHIC

WASHINGTON, D.C.

Published by the National Geographic Society

ISBN: 978-1-4262-1449-3

The National Geographic Society is one of the world's largest nonprofit
scientific and educational organizations. Its mission is to inspire people to
care about the planet. Founded in 1888, the Society is member supported
and offers a community for members to get closer to explorers, connect with
other members, and help make a difference. The Society reaches more than
450 million people worldwide each month through *National Geographic* and other
magazines; National Geographic Channel; television documentaries; music;
radio; films; books; DVDs; maps; exhibitions; live events; school publish-
ing programs; interactive media; and merchandise. National Geographic has
funded more than 10,000 scientific research, conservation, and exploration
projects and supports an education program promoting geographic literacy.
For more information, visit www.nationalgeographic.com.

National Geographic Society
1145 17th Street N.W.
Washington, D.C. 20036-4688 U.S.A.

For information about special discounts for bulk purchases, please contact
National Geographic Books Special Sales: ngspecsales@ngs.org

For rights or permissions inquiries, please contact National Geographic Books
Subsidiary Rights: ngbookrights@ngs.org

Interior design by Katie Olsen/Melissa Farris

Printed in Hong Kong
14/THK/1

CONTENTS

INTRODUCTION

DAILY JOY—LOVELY WORDS, especially when paired together. We all want to experience happiness every day. It's top of mind for women everywhere and the subject of countless books, movies, and late-night conversations. But, as with the search for the proverbial pot of gold at the end of the rainbow, the pursuit of happiness is often frustrating. We wonder: If we want joy so much, why aren't we feeling it? Because we aren't in on the secret: Daily joy requires daily effort.

Effort? That sounds so counterintuitive. Shouldn't joy be effortless, as it was in childhood? As it turns out, it *can* be effortless—but not *reliably*. That's because our brains are wired to look for what's wrong. This inclination, known as the negativity bias, kept our ancestors alive by alerting them to predators, weather changes, poisonous plants, and other dangers. Our negativity bias helped us evolve. But it's also what makes it difficult to notice and enjoy what's good in life. Just think of the last compliment you got . . . and then think about the last criticism. Which came to mind more easily—and more intensely?

But don't despair. You aren't doomed to be unhappy, because you can change your brain. The journal you hold in your hands will help you do just that; a few moments reflecting and writing in these pages will help rewire your brain to notice and savor what's good. And when you take action on the suggestions sprinkled throughout each chapter? A happiness bonanza!

Before you rev into high-achiever mode ("I'll read the entire journal tonight and be blissful by break-fast"), know that *regular practice in small doses* is the key to affecting your general happiness. Since your brain adapts quickly to what's new, elation fades; that's why a move to Hawaii, while initially thrilling, inevitably fades into errands, housekeeping chores, and other routine responsibilities.

The goal of this journal is to dole out pint-size doses of joy and happiness reminders so that your daily efforts bring you the greatest benefit. Each pho-tograph has been carefully selected to nourish your need for beauty and inspiration, which have also been shown to increase happiness. Each exercise has been specifically created to boost your mood and help you thrive.

You may be thinking, "Regular practice? But it's so hard for me to stick to doing anything." Or perhaps you're concerned that joy will become another "should" on your to-do list. You don't want this journal to be something you feel you *have to* do, but you do want to read and write in it regularly. So here are a few tricks to engage in this practice with ease:

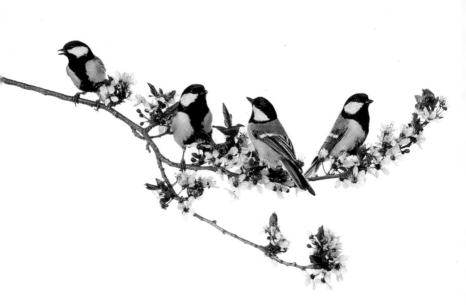

- Move the journal every few days—from your bedside to your desk to the kitchen table. Keep it in your closet or even inside the fridge. Studies show that an effective way of adopting a new habit is to create surprising and constantly changing reminders. Seeing this book in new places will achieve just that.

- Keep your favorite pen and a pair of reading glasses, if needed, with your journal. If you have to go searching for a pen, you may suddenly find yourself washing the dishes or checking email instead of spending a few minutes increasing your joy.

- Ask a friend or two to join you in your quest for joy. Then email or text her to celebrate every time you use this journal, even if you feel silly. Celebration helps a new habit stick.

- Embrace "begin again" as your motto. Everybody falters when adopting a new habit, even one as fulfilling as increasing your daily joy. Instead of giving up when you find your journal buried under old magazines and bills, dust it off and begin again. Forget guilt; choose growth.

- Choose your way. Sure, there's an entry for each day, but so what? You decide how you will use this journal and how often. Maybe you'll choose to use it on the weekends only, or on your morning off, or after exercise class three times a week. Choice moves this practice from a "should"—which means you'll probably rebel against it—into something you do because you want to. And that makes all the difference.

- Personalize the book. Glue pictures of joyful moments on the date they happen or capture something you want to remember in a few words, like the look of pleasure on your co-worker's face when you paid for lunch. Joy is about paying attention.

In the end, this book is a celebration of the precious life you are creating and living every single day. Treat your time with it as time with your heart and soul, and make it absolutely and deliciously yours. You cannot fail at this—it's your daily joy, your way. Enjoy!

• • •

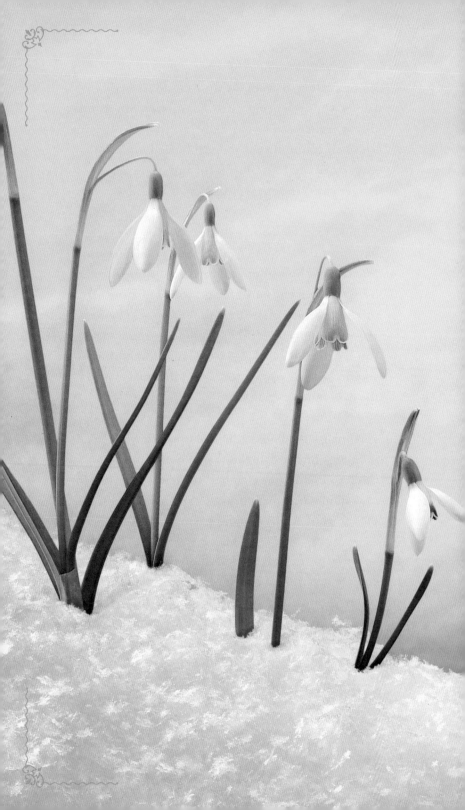

JANUARY

Renewal

JANUARY 1

RENEWAL TIP
Declare Your Basic Needs

Your basic needs—eight hours of sleep, time in
nature, reading for fun—are easy to discount,
especially when life gets busy. But forget them,
and your life can quickly fray. Take a moment
now to name what you need—daily, weekly,
monthly—to feel like yourself. What fills you
up enough to handle what life brings?

• • •

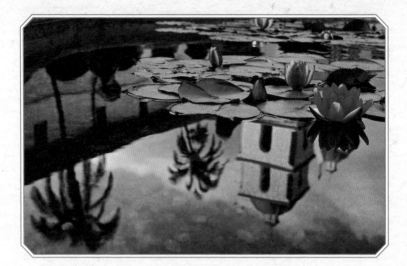

JANUARY 2–3

No one saves us from ourselves but ourselves.
No one can and no one may.
We ourselves must walk the path.

~ BUDDHA

..
..
..
..
..
..
..

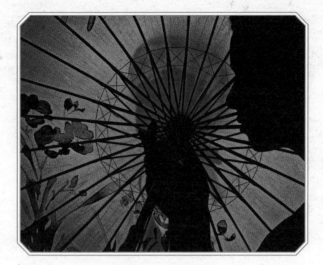

JANUARY 4–5

Just where you are—that's the place to start.

~ PEMA CHÖDRÖN

JANUARY 6

THINK ABOUT . . .
True Renewal

Jot down ten activities that renew you—
not *should* renew you but truly *do*.

HINT: *Start by naming what you wish
you had more time to enjoy.*

• • •

JANUARY 7

TRY THIS
Wake Up Right

How you begin your day can set the tone
for everything that follows. But often,
we awaken with a sense of urgency: so much
to do, so much we wish were already done.
Think about the most delicious way to start
your day and paint a realistic yet nurturing
scenario below. Tomorrow, enact just *one*
element of your desired morning. Starting small
and building is how change happens.

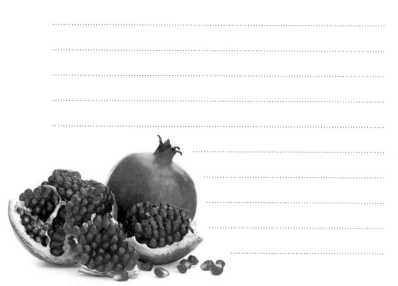

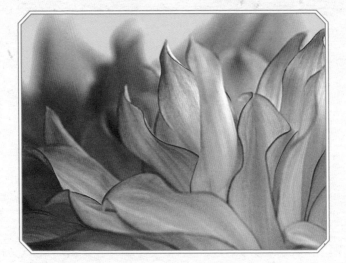

JANUARY 8–9

Look within. Within is the fountain of good,
and it will ever bubble up,
if thou wilt ever dig.
~ MARCUS AURELIUS

..
..
..
..
..
..

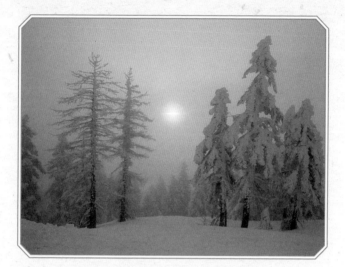

JANUARY 10–11

Joy is what happens to us
when we allow ourselves to recognize
how good things really are.

~ MARIANNE WILLIAMSON

JANUARY 12

RENEWAL TIP
Court Yourself

We are so good at taking care of others—
spending countless hours to help our partners,
friends, children, and even our pets feel beloved
and supported. Imagine caring for yourself
with the same level of attention that you show
others. What would you give yourself? Think,
"How can I show myself how much I value me?"
Shower yourself with kindness.

. . .

JANUARY 13

THINK ABOUT . . .
Rising Above

Self-nurturing also includes what you *don't do:*
for example, avoiding cruel self-criticism,
overextending yourself, or agreeing to
something you really don't want to do.
What negativity will you eliminate this month?

• • •

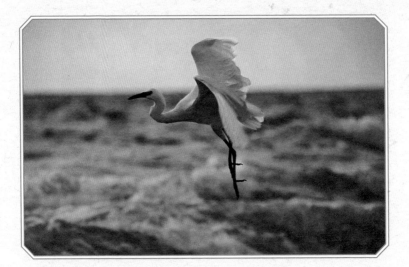

JANUARY 14–15

Without forgiveness, there is no future.

~ DESMOND TUTU

..
..
..
..
..
..
..
..

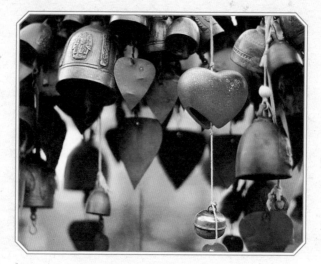

JANUARY 16–17

Put your ear down close to your soul
and listen hard.

~ ANNE SEXTON

...
...
...
...
...
...
...
...

JANUARY 18

RENEWAL TIP
Choose This, Not That

It's the rare day that goes exactly as planned, the
rare week when something doesn't go awry.
Yet we often act as though disappointments
and interruptions are the exception in life,
rather than the rule, making it difficult
to bounce back. Instead, plan ahead
using a "this, not that" approach:

When X happens (deadline moved up),
I will do Y (walk around the block listening
to one uplifting song) instead of Z
(call co-worker to gossip). Sketch out three
"this, not that" scenarios now.

• • •

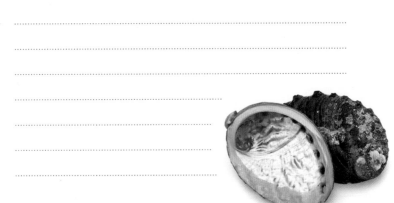

JANUARY 19

TRY THIS
Say Yes to You

Most people have less-than-helpful
beliefs about why taking care of themselves
isn't possible. Common refrains include
"It's selfish," "I have to work hard to stay
competitive," "I don't need it," and so on.
Name your beliefs below by completing
this sentence: I find it difficult to care
for myself because _____. Doing so
will help you drop this negative reasoning
and give yourself the nurturing you deserve.

• • •

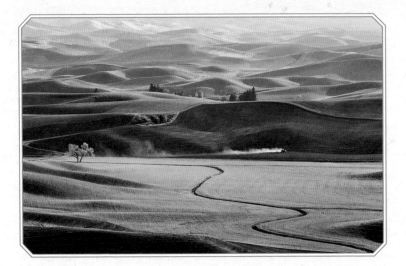

JANUARY 20–21

*At some point in life the world's beauty
becomes enough. You don't need to photograph,
paint, or even remember it. It is enough.*

~ TONI MORRISON

..

..

..

..

..

..

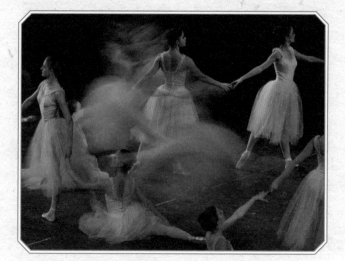

January 22–23

Dance, when you're broken open.
Dance, if you've torn the bandage off.
Dance in the middle of the fighting.
Dance in your blood.
Dance when you're perfectly free.

~ RUMI

...
...
...
...
...

JANUARY 24

THINK ABOUT . . .
Your Body's Wisdom

Your body is wise and knows what it needs
to renew. Today, ask yourself, "What do you need
to feel refreshed? What part of you could use
some attention?" Let your body answer directly.
You may find yourself stretching, sighing, rolling
out your yoga mat, or scheduling a massage.
Act on what your body wants—and needs.

. . .

*Look inside. That way lies dancing
to the melodies spun by your own heart.
This is a symphony. All the rest are jingles.*

~ ANNA QUINDLEN

..
..
..
..
..
..
..
..

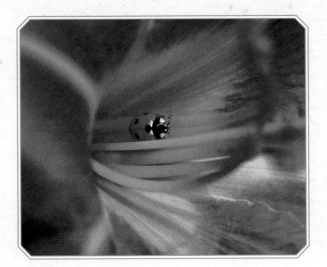

JANUARY 27–28

*Above all, watch with glittering eyes the whole world
around you because the greatest secrets
are always hidden in the most unlikely places.
Those who don't believe in magic will never find it.*

~ ROALD DAHL

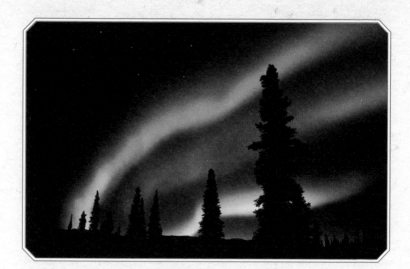

JANUARY 29–30

Every great dream begins with a dreamer.
Always remember, you have within you the strength,
the patience, and the passion to reach
for the stars to change the world.

~ HARRIET TUBMAN

JANUARY 31

TRY THIS
Invite Rest

Renewal helps you dream big *and* take action.
But first, you may need to rest. How can you invite
more ease and relaxation into your life today?

HINT: *Look for "shoulds" and "have tos." Ask yourself,*
"Do I really have to complete this task today? Why?"
Open up space to make your well-being a top priority.

• • •

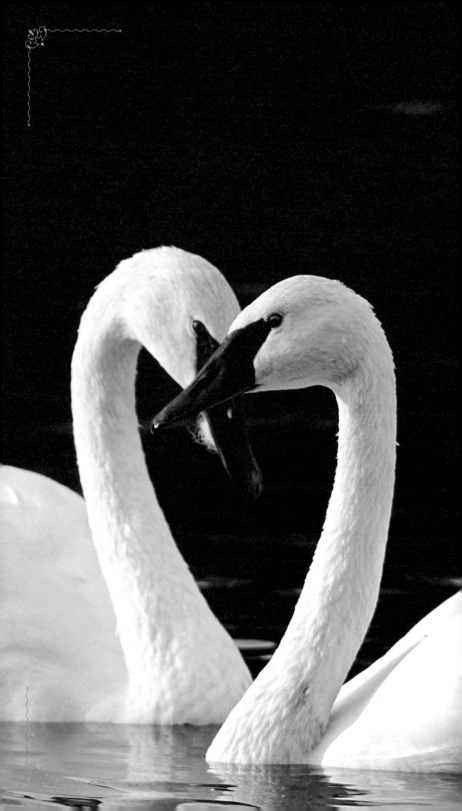

FEBRUARY

Love

FEBRUARY 1

LOVE TIP
Open Your Heart

To love is to have an open heart. To cultivate
openness, try this: Invite your face to soften,
your shoulders to descend, your hands to open.
Silently repeat this mantra inspired by Zen
Buddhist monk and teacher Thich Nhat Hanh,
putting your attention on your heart:

Inhaling I smile

Exhaling, my heart gently opens

Reflect on a person with whom you would like to
cultivate more openness. The next time you find
yourself with that person, repeat this exercise;
nobody needs to know what you're doing.
You might find the effects miraculous.

• • •

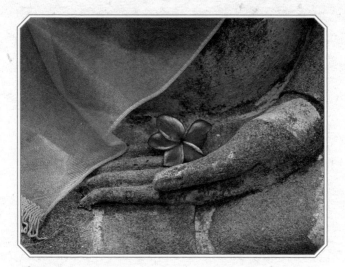

FEBRUARY 2–3

*You yourself, as much as anybody in the
entire universe, deserve your love and affection.*

~ BUDDHA

..
..
..
..
..
..
..

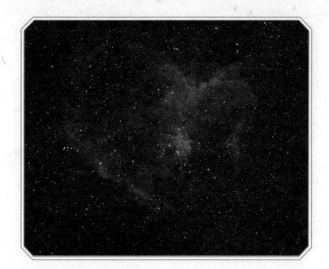

FEBRUARY 4–5

It is only with the heart that one can see rightly;
what is essential is invisible to the eye.

~ ANTOINE DE SAINT-EXUPÉRY

FEBRUARY 6

TRY THIS
Think With Your Heart

Your heart has a "brain" of about 40,000
neurons that sense, feel, learn, and remember.
The best way to tune your heart brain to reduce
stress and improve your resiliency, clarity, and
empathy is to recall a time when you felt good
and reexperience that emotion, savoring it.

Of course, when you're stressed, it can be hard
to remember the good times. Prep your heart
brain by recalling ten feel-good moments—
not necessarily big events, but ones
that make you peaceful, relaxed, or happy.
The next time you're feeling tense,
relive one in full sensory detail.

• • •

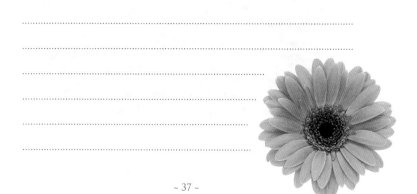

FEBRUARY 7–8

To lose balance, sometimes, for love,
is part of living a balanced life.
~ ELIZABETH GILBERT

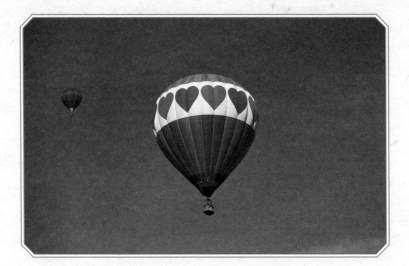

FEBRUARY 9–10

We love because it's the only true adventure.

~ NIKKI GIOVANNI

February 11–12

Forgiveness is the final form of love.

~ Reinhold Niebuhr

...
...
...
...
...
...
...
...

FEBRUARY 13

THINK ABOUT . . .
Strengthening Forgiveness

Hanging on to old hurts and grievances makes
it harder to love. Forgiving doesn't mean
forgetting or becoming a doormat. It means
declaring, "I will no longer poison myself
by rehashing the past—and I trust myself
to take care of myself in the future."
What retreads of past hurts—things done
to you and done *by* you—are you ready
to stop rewinding? List them now.

• • •

FEBRUARY 14

LOVE TIP
Put Love Into Action

Everyone knows what it's like to lash out
in anger at someone he or she loves.
It's devastating. The next time you're hot
with anger, hit your inner pause button.
Think about someone you admire—a mentor,
a loving parent, a dear friend. How would he
or she respond? Imagine yourself doing
the same. Try this now, priming yourself
for the next time you're in danger of losing
your temper or being judgmental.

FEBRUARY 15–16

Let the beauty of what you love be what you do.
~ RUMI

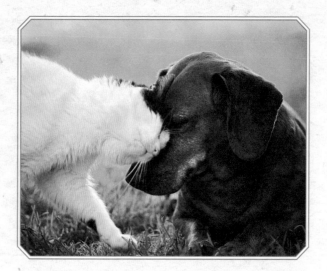

February 17–18

*Each friend represents a world in us,
a world possibly not born until they arrive.
And it is only by this meeting
that a new world is born.*

~ ANAÏS NIN

FEBRUARY 19

TRY THIS
Follow Your Love Code

Love flourishes through generosity.
But we often find it easier to be more giving
with our friends than with our family, partners,
and children, who can push our buttons
in a different way.

What "love code" have you learned from
your friendships that you'd like to apply in
your family relationships? Perhaps it's to listen
without interrupting, to forgo blame,
to compliment lavishly, or to play together.
How will you allow your friendship wisdom
to play out with the rest of your loved ones?

• • •

FEBRUARY 20

❧

THINK ABOUT . . .
Your Love Biography

You've been loved in so many ways in your life:
by teachers, mentors, pets, friends, family—
even strangers! Our culture focuses strongly
on romance, which, amazing though it is,
encompasses only one narrow aspect of love.
Pen your love biography and grow your affection
by listing a few of the ways you've been loved
and by whom. You may find yourself reaching
for extra pages because this feels so good!

• • •

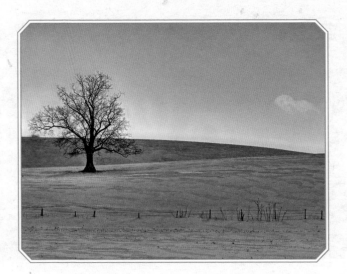

February 21–22

*Life without love is like a tree
without blossom or fruit.*

~ Kahlil Gibran

..
..
..
..
..
..
..

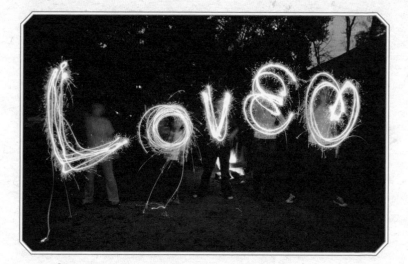

February 23–24

The one thing we can never get enough of is love.
And the one thing we never give enough of is love.
~ HENRY MILLER

...
...
...
...
...
...
...
...

*A very small degree of hope is sufficient
to cause the birth of love.*

~ STENDHAL

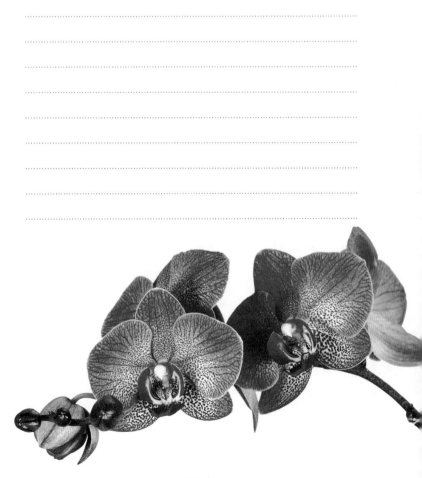

FEBRUARY 27

LOVE TIP

Express Love Every Chance You Get

Whether it's going back in the house—
even when you're late—to kiss your special
someone goodbye, writing a quick "I love you
because . . ." email, telling your friend why you
appreciate her, or complimenting a stranger
in the grocery store, why not make a vow
to show the world more love going forward?
Where might you begin?

• • •

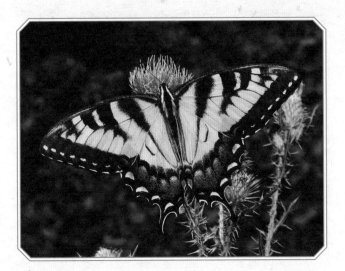

FEBRUARY 28–29

Love is like quicksilver in the hand.
Leave the fingers open and it stays.
Clutch it, and it darts away.

~ DOROTHY PARKER

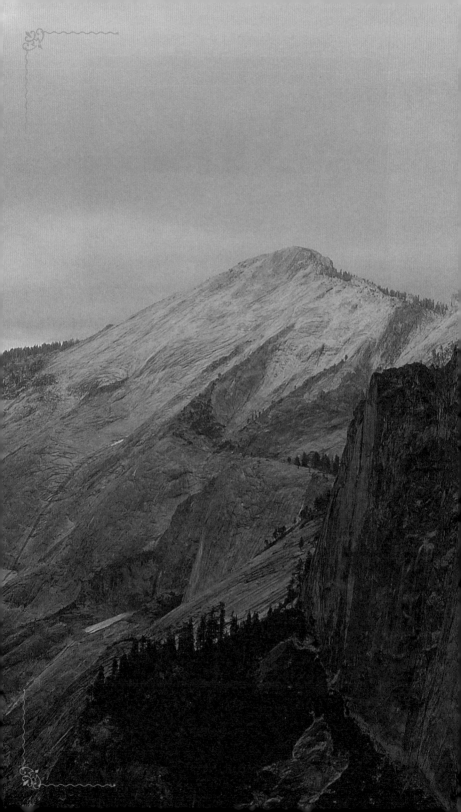

MARCH

Authenticity

MARCH 1

AUTHENTICITY TIP
Decide You Are Enough

You yearn to be valued for who you are,
not for what you do. Yet it can be terrifying
to show your true self. *Will you be enough?*
Accept that the only person who can answer
that question is *you*. Throughout the day,
ask yourself, "Am I giving enough
by *my* standards?" If the answer is no,
try to determine what is interfering with
your sense of satisfaction. Is it perfectionism,
people pleasing, or spreading yourself too thin?
Become intimate with what fulfills *you*.

• • •

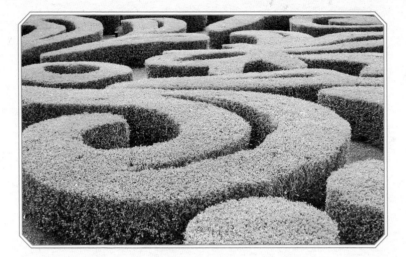

MARCH 2–3

Be thine own palace, or the world's thy jail.

~ JOHN DONNE

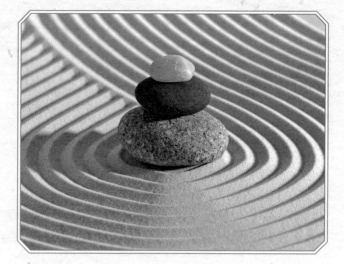

MARCH 4–5

Happiness is when what you think, what you say,
and what you do are in harmony.

~ MAHATMA GANDHI

MARCH 6–7

What is passion?
It is surely the becoming of a person.
~ JOHN BOORMAN

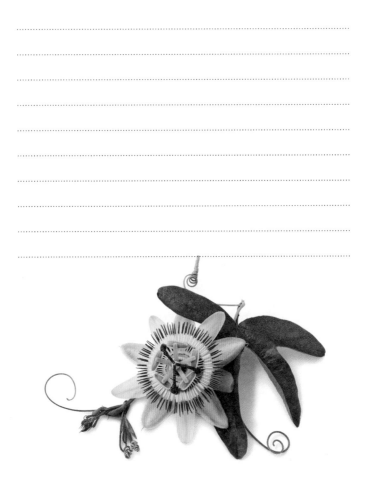

MARCH 8

TRY THIS

Turn Your Inner Critic Into an Ally

We sometimes run the risk of drifting into
inauthenticity because we believe the voice
in our head that says we aren't doing something
right, we don't fit in, we're not smart enough,
and so on. Quiet your inner critic and empower
yourself by writing down your harshest personal
criticisms. Then address each statement out loud
(hearing yourself is important), one by one.
You might tell your inner critic: "Thank you
for sharing. What you say may or may not
be true, but it's certainly not helpful. I won't
listen to you until you can speak constructively
and kindly to me." You'll find that this exercise
will liberate you and help you flourish.

• • •

..

..

..

..

..

..

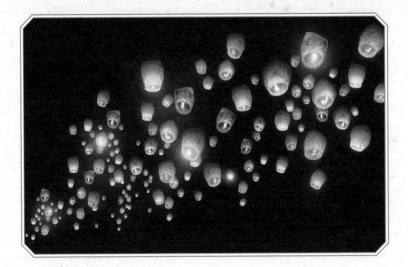

MARCH 9–10

*How many cares one loses when one decides
not to be something, but to be someone.*

~ COCO CHANEL

..
..
..
..
..
..
..

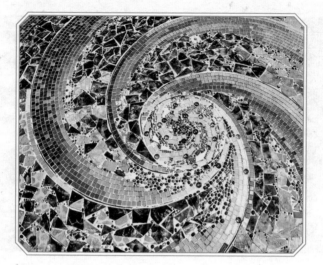

MARCH 11–12

If you have nothing at all to create,
then perhaps you create yourself.
~ CARL JUNG

...

...

...

...

...

...

...

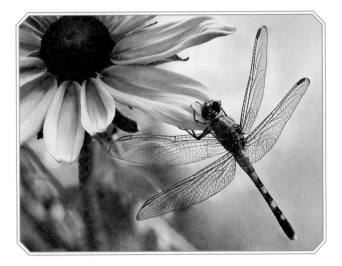

MARCH 13–14

*Just trust yourself, and then
you will know how to live.*

~ JOHANN WOLFGANG VON GOETHE

...

...

...

...

...

...

...

...

MARCH 15

THINK ABOUT . . .
The Patterns of Your Authentic Self

Reflect on the moments you feel most
authentic—most alive and most at home
in yourself. Read over your list and look for
any patterns: people, places, or activities that
support your being true to you. Give yourself
more of those experiences—starting now!

• • •

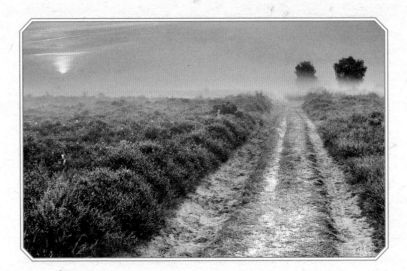

MARCH 16–17

It's our choices that show what we truly are,
far more than our abilities.

~ J. K. ROWLING

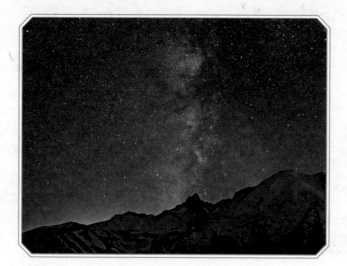

MARCH 18–19

Everything in the universe is within you.
Ask all from yourself.

~ RUMI

...
...
...
...
...
...
...
...

March 20–21

*The shoe that fits one person pinches another;
there is no recipe for living that suits all cases.*

~ Carl Jung

MARCH 22

AUTHENTICITY TIP
Relax Toward Authenticity

To get in tune with yourself, it helps to relax
your body. Try this: Take a full breath and tense
up your whole body—face, jaw, hands, and even
feet. Tense up even tighter, holding your breath.
Now let go with a long *Ahhhh.*

Give yourself an ear or hand rub while singing your
own praises, perhaps completing the sentence:
"I'm proud of you for _____."
Quick body breaks like these lower your
stress hormones, improve your concentration,
and promote self-compassion.

• • •

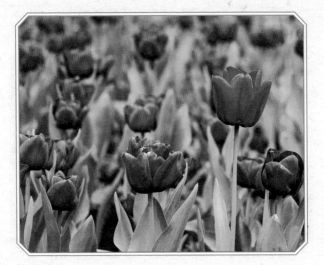

MARCH 23–24

The privilege of a lifetime is being who you are.
~ JOSEPH CAMPBELL

MARCH 25–26

*To be nobody but yourself—in a world
which is doing its best, night and day, to make you
everybody else—means to fight the hardest battle
which any human being can fight.
Never stop fighting.*

~ E. E. CUMMINGS

...
...
...
...
...

MARCH 27–28

We make a living by what we get.
We make a life by what we give.
~ WINSTON CHURCHILL

..
..
..
..
..
..
..
..
..

MARCH 29

TRY THIS

Relish the Rewards of Being Genuine

Look back at March 15, when you recalled
specific moments of being authentically
yourself. Today, reflect on the benefits that
came from those moments. How did you feel?
Did you grow closer to someone? Feel more
peaceful or creative? Stand up for something
that matters to you? Describe the gifts you
have already received by simply being your
unencumbered self. Embrace that goodness
and be on the lookout for it in your future.

• • •

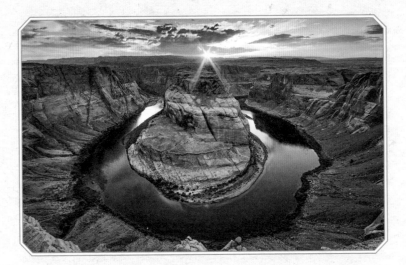

MARCH 30–31

When you do things from your soul,
you feel a river moving in you, a joy.

~ RUMI

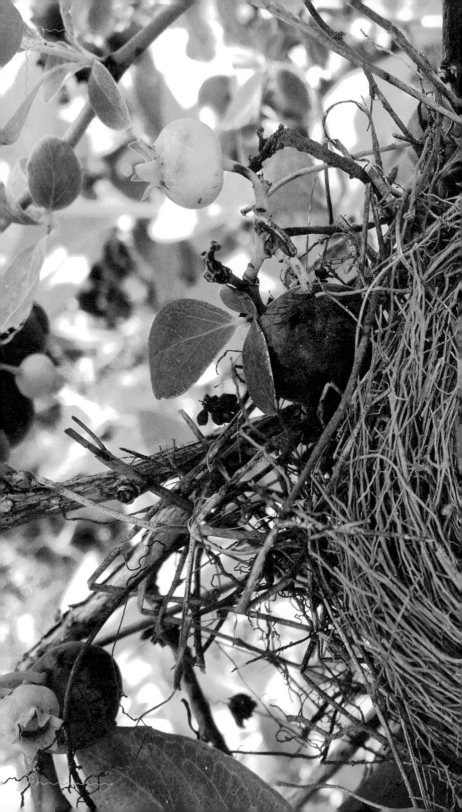

APRIL

Growth

APRIL 1

GROWTH TIP
Choose Growth, Not Self-Improvement

Self-improvement is often based on the belief
that something in you needs fixing; if only
you could change your _____ (eating habits,
bank balance), then you'd finally be _____
(happy, lovable). Growth, on the other hand,
is rooted in knowing that you are, at your core,
good. This core goodness is unchangeable.
It cannot be sullied or improved on, and it
serves as a springboard for seeking new freedoms
and enjoyment. Can you feel the difference?

• • •

APRIL 2–3

*Life is a process of becoming, a combination of states
we have to go through. Where people fail is that
they wish to elect a state and remain in it.*

~ Anaïs Nin

APRIL 4–5

It is quite true what philosophy says:
that life must be understood backwards.
But then one forgets the other principle:
it must be lived forwards.

~ SØREN KIERKEGAARD

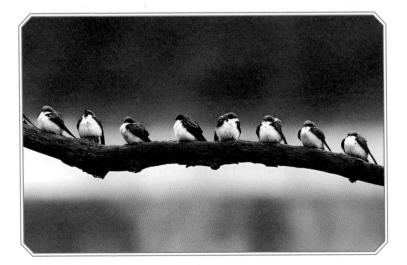

April 6–7

Arrange whatever pieces come your way.

~ Virginia Woolf

..
..
..
..
..
..
..
..

APRIL 8

TRY THIS
Embrace the Spiral of Growth

Growth happens in a spiral. We revisit the same issues and patterns from a *slightly* different perspective with *slightly* wiser insights. We often think we should grow in a linear, upward trajectory—but that's just not how being human works.

Appreciate the incremental changes you are making by writing about one or two recent turns on your spiral. What familiar sticking points did you encounter? How did you deal with them in a *slightly* more skillful way? How does this motivate you to proceed?

• • •

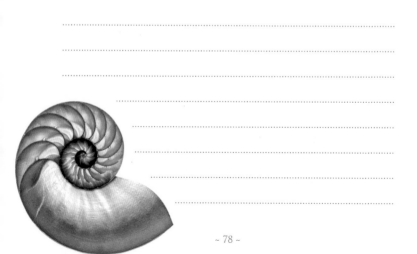

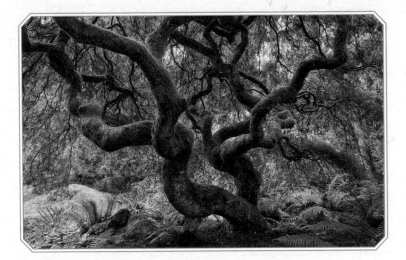

APRIL 9–10

All changes, even the most longed for,
have their melancholy; for what we leave behind us
is a part of ourselves; we must die to one life
before we can enter another.

~ ANATOLE FRANCE

...

...

...

...

...

...

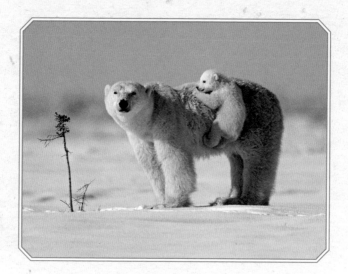

APRIL 11–12

*When we were children, we used to think
that when we were grown-up, we would
no longer be vulnerable. But to grow up
is to accept vulnerability . . . to be alive
is to be vulnerable.*

~ MADELEINE L'ENGLE

APRIL 13–14

*It is impossible to live without failing at something—
unless you live so cautiously that you might as well
not have lived at all, in which case
you have failed by default.*

~ J. K. ROWLING

APRIL 15

THINK ABOUT . . .
Your Sweetest Disappointments

What are your most fruitful failures,
the mistakes that delivered a surprising
harvest? List the failure and the fruit.
Of course, you would have liked the fruit
to ripen in some easier way—we all do!
Let the fruit give you the courage to face
future failures: the essence of growth.

. . . .

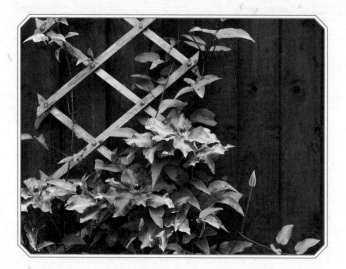

APRIL 16–17

Experience teaches only the teachable.

~ ALDOUS HUXLEY

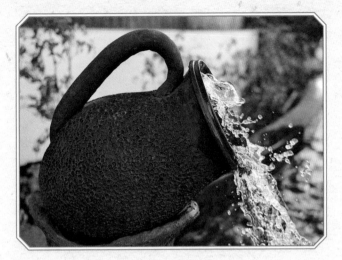

APRIL 18–19

A jug fills drop by drop.

~ BUDDHA

..
..
..
..
..
..
..
..
..

APRIL 20

❦

GROWTH TIP
Ask Bottomless Questions

Answers are helpful when it comes to getting
directions and doing your taxes, but they're
highly overrated when it comes to personal
growth. When you get an answer, you often
stop being curious and forgo new ideas
and solutions. Instead, try asking bottomless
questions—the kind that tantalize and stretch
you. For example, "How can I love more?"
or "What do I want to create today?" This sort
of reflection brings something more precious
than a right answer: It inspires growth.

• • •

..
..
..
..
..
..
..

APRIL 21–22

Growth itself contains the germ of happiness.
~ PEARL S. BUCK

..
..
..
..
..
..
..
..
..

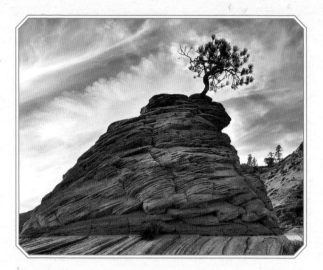

APRIL 23–24

Live out your imagination, not your history.

~ ARTHUR BRYAN

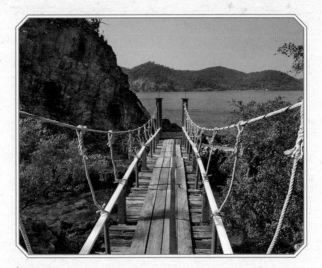

APRIL 25–26

Action may not always bring happiness;
but there is no happiness without action.

~ BENJAMIN DISRAELI

...
...
...
...
...
...
...
...

APRIL 27

TRY THIS
Know Your Motives

We stick with the hard work that growth requires
when we are motivated by something we desire:
an end goal that we keep front and center.
Why have you chosen to invest your money
and time in personal growth? What led you
to participate in this journal?

Whatever your answers, they are perfect if they
truly matter to you. Ignore what you think
should motivate you to grow ("self-fixing,"
for example) and focus on what keeps you
inspired to be a more joyous and genuine you.
Flag this page and remind yourself often.

• • •

...

...

...

...

...

...

...

APRIL 28

GROWTH TIP
Respect Yourself

Who is with you every moment of your life?
Who gently (and sometimes insistently) guides
you toward what is best for you? Who allows
you to experience everything that life has
to offer? You've guessed by now: your body.
Yet how often do you ignore, override, dismiss,
or belittle your irreplaceable physique?
Tune into your body's signals: the funny
feeling in your stomach, the chill running
up your arm. Respond to each need
and see what growth—and ease—results.

• • •

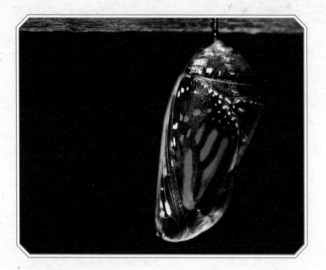

APRIL 29–30

In the long run, we shape our lives,
and we shape ourselves. The process never ends
until we die. And the choices we make
are ultimately our responsibility.
~ ELEANOR ROOSEVELT

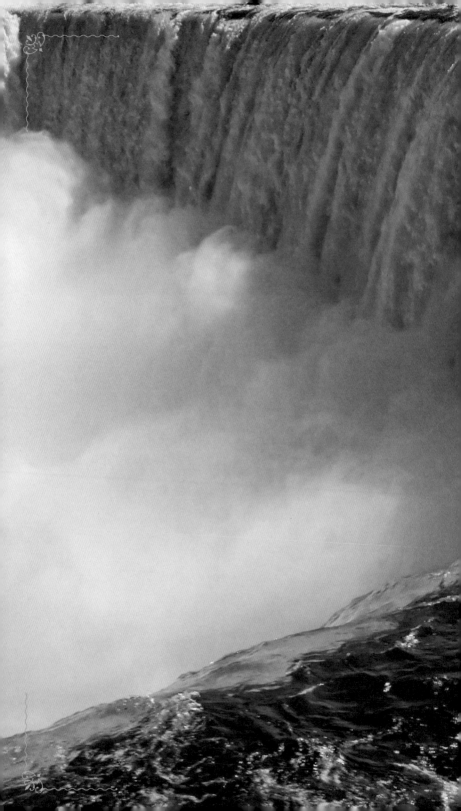

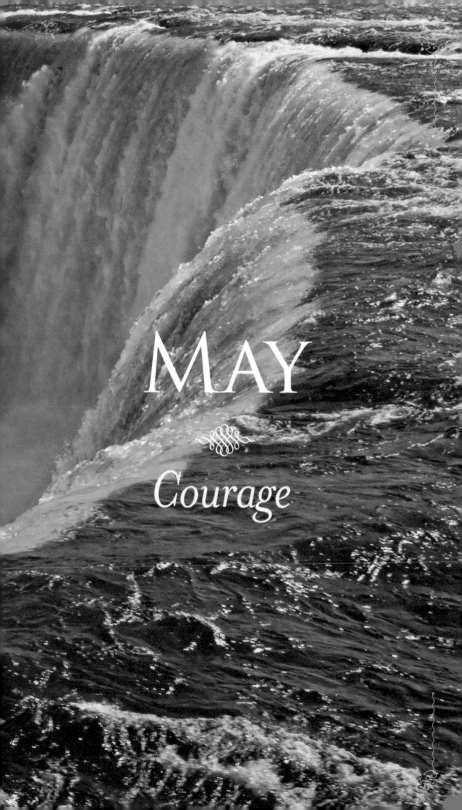

MAY

Courage

MAY 1

COURAGE TIP
Ordinary Daring

It's tempting to frame bravery as something
extraordinary that you do in a crisis, when it's
actually a quality you use every day. Each time
you dare to express an idea, honor a desire,
or love someone freely and without expectation,
you are courageous. Today, notice your
ordinary moments of daring. Congratulate
yourself for each one. Bonus: Enlist a friend
or a family member to celebrate with you.

· · ·

MAY 2–3

*The courage of life is often a less dramatic spectacle
than the courage of the final moment;
but it is no less a magnificent mixture
of triumph and tragedy.*

~ JOHN F. KENNEDY

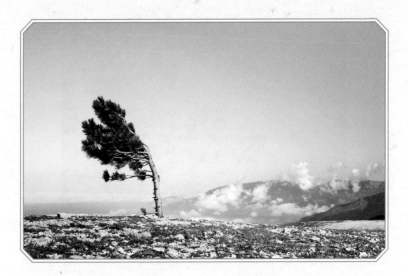

MAY 4–5

All you need is confidence in yourself.
There is no living thing that is not afraid
when it faces danger. The true courage is
in facing danger when you are afraid,
and that kind of courage you have in plenty.

~ L. FRANK BAUM

...

...

...

...

...

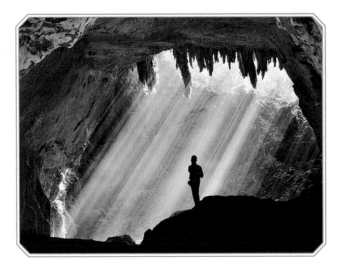

MAY 6–7

Everyone has a talent.
What's rare is to follow it
to the dark places where it leads.

~ ERICA JONG

MAY 8

TRY THIS

Develop Your Capacity for Courage

Where in your life do you long
for more courage? Making decisions?
Expressing yourself creatively? Challenging
yourself physically? Close your eyes.
Imagine yourself acting bravely in that
exact situation. What would you do?
How would it feel? Be sure to see yourself
in action—for example, speaking your mind
with confidence and clarity. Research shows
that using your imagination is highly effective
in motivating your future behavior.

• • •

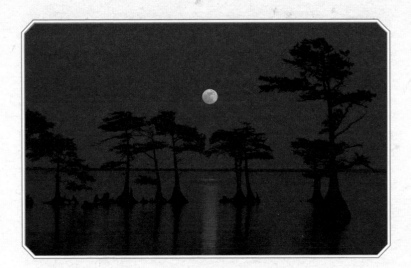

MAY 9–10

Fortune favors the bold.

~ VIRGIL

...

...

...

...

...

...

...

...

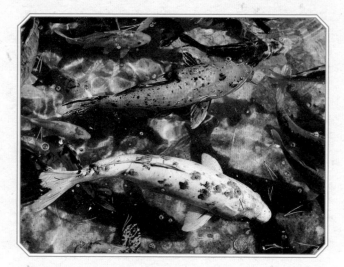

MAY 11–12

It takes a great deal of bravery
to stand up to our enemies,
but just as much to stand up to our friends.

~ J. K. ROWLING

I'm not afraid of storms,
for I'm learning how to sail my ship.
~ LOUISA MAY ALCOTT

...
...
...
...
...
...
...
...

MAY 15

THINK ABOUT . . .
Where to Find Motivation

Courage is as contagious as fear. What books,
films, stories, and people inspire you
to act bravely? They may be examples from
history or literature, or you may even make up
a personal superhero who possesses exactly
the qualities you admire. Inspire yourself
to be more courageous by listing—or creating—
your most prized role models.

. . .

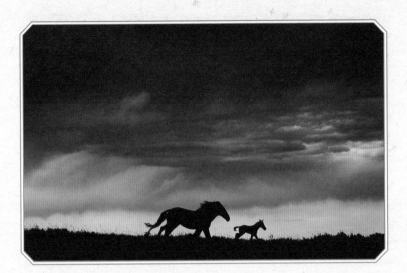

MAY 16–17

Courage is being scared to death—
and saddling up anyway.
~ JOHN WAYNE

...
...
...
...
...
...
...
...

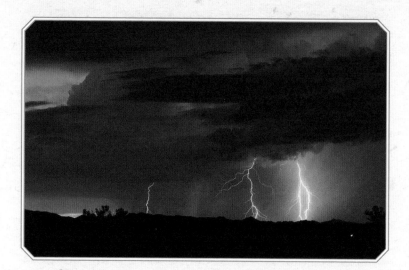

MAY 18–19

Let me not pray to be sheltered from dangers
but to be fearless in facing them.
~ RABINDRANATH TAGORE

MAY 20–21

The most courageous act is to think for yourself.
Aloud.

~ COCO CHANEL

...
...
...
...
...
...
...
...
...
...
...

MAY 22

COURAGE TIP
Befriend Fearlessness

We are all afraid. Courage is not the
absence of fear; it's skillfully coping with fear
without letting it control you. Consider those
around you: What is your friend afraid of?
Your neighbor? Recognize that you are not
alone in feeling afraid from time to time.

When fear does show up—whether it's signaled
by a twitch in your stomach, a sudden sugar
craving, or a sleepy confusion—greet it like
a friend. Exhale slowly to calm your nervous
system and then give your fear a chance
to be heard—because once you've heard it,
it often settles. After listening, thank your fear
and reaffirm that you—and not your fear—
will decide what's best.

• • •

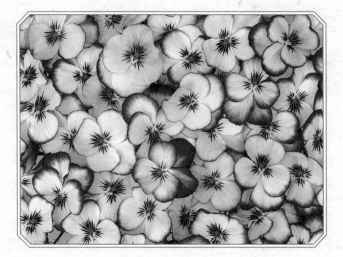

MAY 23–24

*Life shrinks or expands in proportion
to one's courage.*

~ ANAÏS NIN

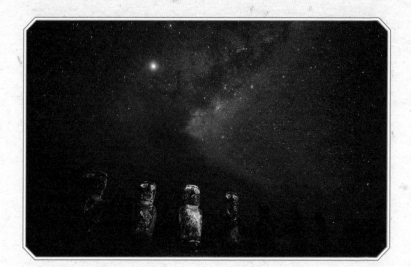

MAY 25–26

The weak can never forgive.
Forgiveness is the attribute of the strong.
~ MAHATMA GANDHI

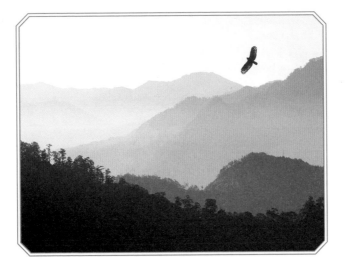

MAY 27–28

True bravery is shown by performing without witness what one might be capable of doing before all the world.

~ FRANÇOIS DE LA ROCHEFOUCAULD

MAY 29

TRY THIS
Tell Your Courage Story

Imagine sitting with a circle of trusted friends.
The conversation turns to the bravest thing
you've ever done. One person talks about taking
care of her dying dad, another about adopting
her daughter, another about starting over again
after a divorce. Now it's your turn: Write the
first story of courage that comes to mind.
Don't overthink, just record.

• • •

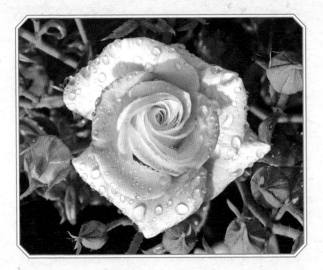

MAY 30–31

When in doubt, tell the truth.

~ MARK TWAIN

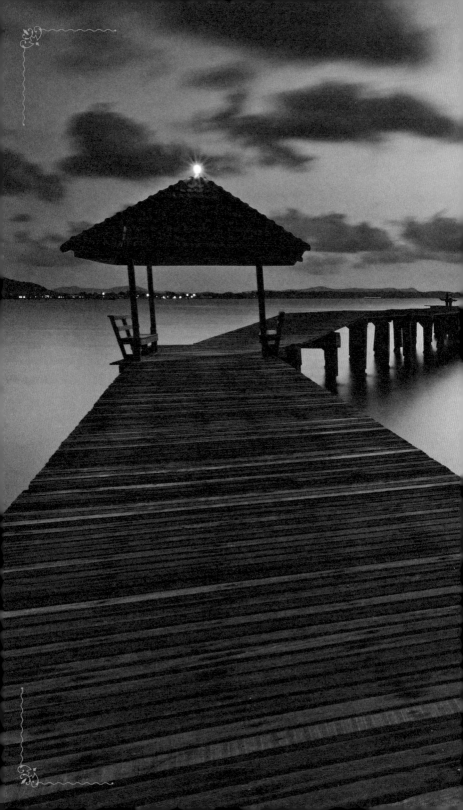

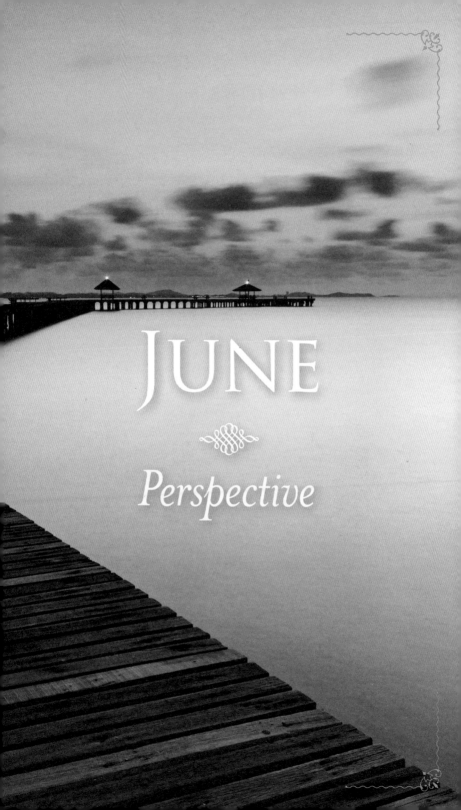

JUNE

⚜

Perspective

JUNE 1

PERSPECTIVE TIP
Question Your Assumptions

Rashomon, a famous Japanese film, portrays
a single event from four characters' perspectives.
In each version, the event depicted changes
drastically. You begin to wonder: What *is*
the truth? What really happened?

The same is true of your life: What you
assume is the truth is almost entirely your
interpretation of events. Our brains are
constructed to make up stories. Gain precious
perspective by questioning your assumptions—
especially when you're adamant, angry,
or beating yourself up. Get curious:
What are the facts? What could you prove
to someone else? This is trickier—
and more rewarding—than it sounds.

• • •

JUNE 2–3

❧

There are no facts, only interpretations.

~ **FRIEDRICH NIETZSCHE**

...
...
...
...
...
...
...
...

June 4–5

Since we cannot change reality,
let us change the eyes which see reality.
~ Nikos Kazantzakis

JUNE 6–7

We already have everything we need.
~ PEMA CHÖDRÖN

...
...
...
...
...
...
...
...
...
...
...

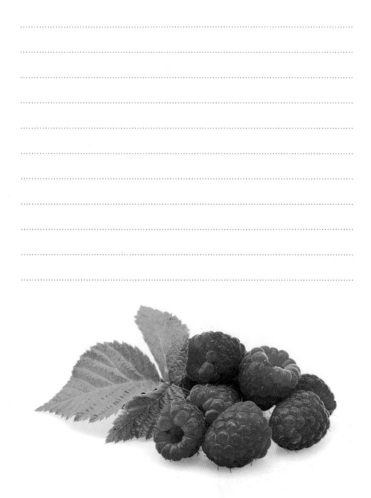

JUNE 8

THINK ABOUT . . .
What Really Matters

How often have you looked back
at an event or decision and wondered,
"What was I so worked up about?"
Apply that soothing perspective of distance
to your current concerns. List each worry
of the moment and then ask yourself,
"What will matter in 10 years? In 20?
At the end of my life?" Then, next to each
listing, record what you discover
through your new outlook.

• • •

June 9–10

*Look at everything as though you were seeing it
for either the first or the last time.
Then your time on earth will be filled with glory.*

~ Betty Smith

...
...
...
...
...
...
...

JUNE 11–12

I never lose sight of the fact that just being is fun.
~ KATHARINE HEPBURN

...
...
...
...
...
...
...
...

JUNE 13–14

One's destination is never a place,
but rather a new way of looking at things.
~ HENRY MILLER

..
..
..
..
..
..
..
..

JUNE 15

TRY THIS
Humor Yourself

There's no doubt about it: Laughter—
especially at yourself—can rouse you out of a rut.
Describe the funniest moments in your recent
history. (And if you find yourself coming up
blank, it might help to query friends and family.
Recalling those silly times together will be
a hoot in itself!) Next time you're feeling stuck,
revisit this list for a restorative chuckle.

• • •

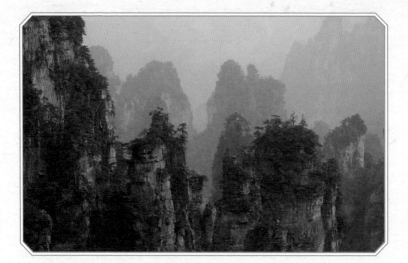

JUNE 16–17

The years teach much which the days never know.
~ RALPH WALDO EMERSON

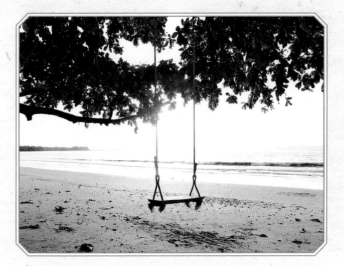

JUNE 18–19

*How we spend our days is, of course,
how we spend our lives.*

~ ANNIE DILLARD

June 20–21

It does not do to dwell on dreams and forget to live.

~ J. K. ROWLING

...
...
...
...
...
...
...

JUNE 22

PERSPECTIVE TIP
Send Joy

We've all had the experience of worrying
about someone and feeling powerless. Try this:
As you inhale, concentrate on what you want
for your friend—perhaps that she be healthy
and at peace. As you exhale, send those wishes
to her. Do this a few times, relaxing
and breathing deeply. You can also do this
for families, communities, animals—
anyone or anything that is clouding
your heart with worry.

• • •

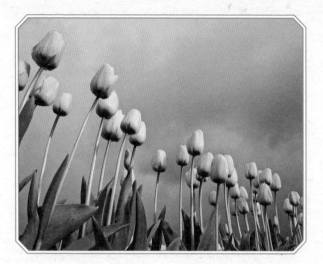

June 23–24

To make the best use of what is in your power,
take the rest as it happens.

~ Epictetus

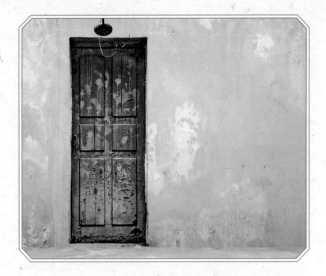

JUNE 25–26

If you shut the door to all errors,
truth will be shut out.

~ RABINDRANATH TAGORE

JUNE 27

⁂

THINK ABOUT . . .
Dependable Mood Shifters

Jot down ten ways you can reliably shift
your mood: a ramble in nature, a hot bath
with lavender oil, volunteering with kids,
a restorative yoga class. Create a catalog
of your best resets. The next time you're
feeling low, turn to one of these simple tricks.

• • •

JUNE 28

PERSPECTIVE TIP
Surprise Yourself

We thrive on novelty. In fact, we can lose
motivation without a regular dose of it.
What area of your life feels bogged down, dull,
or ho-hum? Maybe your job or your weekend
plans? Brainstorm *little* ways you can freshen up
one area: taking a different route to work,
trying a new exercise class at lunchtime,
signing up for salsa lessons with your partner,
inviting neighbors to co-create a progressive
dinner party. The trick to this tip: Keep trying
new things because novelty wears off—fast.

• • •

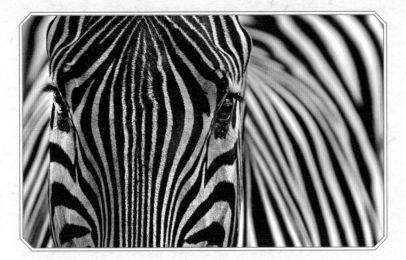

JUNE 29–30

To see what is in front of one's nose
needs a constant struggle.
~ GEORGE ORWELL

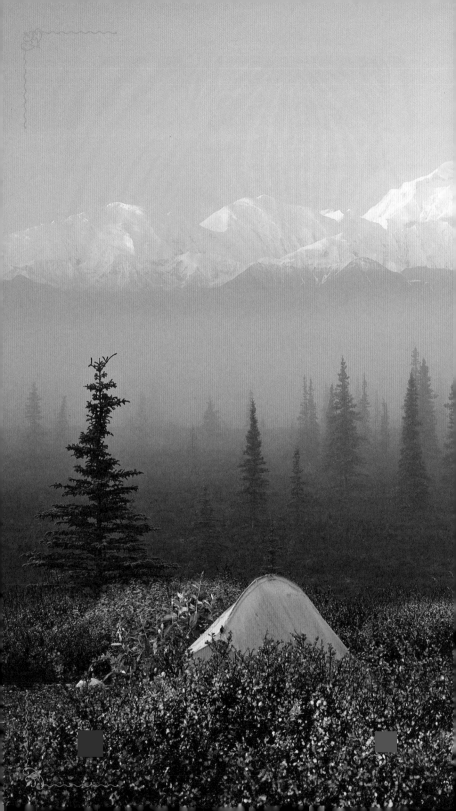

JULY

Adventure

JULY 1

ADVENTURE TIP
Nurture Your Adventure Mood

We thrive on variety, yet we also resist it—
often because we are busy, tired, or afraid
of change. Weeks and months can go by in a
"same old, same old" rut. You crave adventure,
but then another Friday night finds you
watching a movie at home, eating pizza.
If your mood is hindering you from exploring,
give yourself an adventure pep talk: "I might not
feel like it right now, but I'll be refreshed once
I'm in action," or "I'll probably make mistakes
if I take that cooking class, but so what?"

Stop waiting to be in the mood for adventure—
act now! Then afterward, note how you
feel below. That will be enough to encourage
the next adventure!

• • •

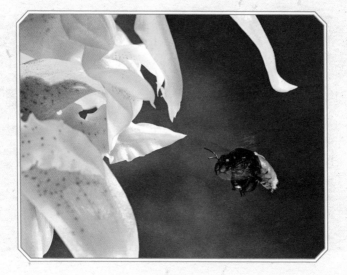

July 2–3

*Life was meant to be lived, and curiosity
must be kept alive. One must never,
for whatever reason, turn his back on life.*

~ Eleanor Roosevelt

...
...
...
...
...
...
...

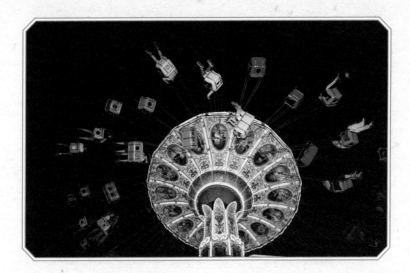

JULY 4–5

Throw your dream into space like a kite,
and you do not know what it will bring back:
a new life, a new friend, a new love,
a new country.

~ ANAÏS NIN

..
..
..
..
..
..

JULY 6–7

*Develop interest in life as you see it; in people,
things, literature, music—the world is so rich,
simply throbbing with rich treasures, beautiful souls
and interesting people. Forget yourself.*

~ HENRY MILLER

JULY 8

TRY THIS
Start Your Thimble List

A bucket list is about once-in-a-lifetime
adventure: skydiving, hiking the Pacific
Crest Trail, sailing the Greek isles.
A thimble list, on the other hand, is about
all the tiny thrills you want to experience *often:*
surprising your friend for lunch, getting
a massage, eating all the raspberries you want.
Bucket lists are inspiring, but most of life
is lived in the thimble list zone—and these
simple pleasures can be enormously satisfying.
Write your thimble list now. Share it
with dear friends.

• • •

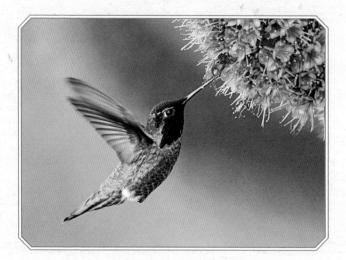

JULY 9–10

Life itself is the proper binge.

~ JULIA CHILD

...
...
...
...
...
...
...
...

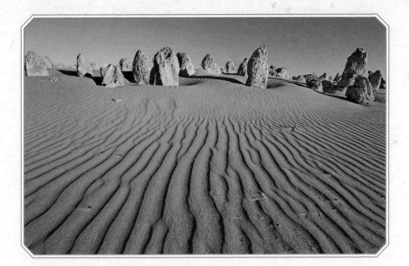

JULY 11–12

It is good to love the unknown.

~ CHARLES LAMB

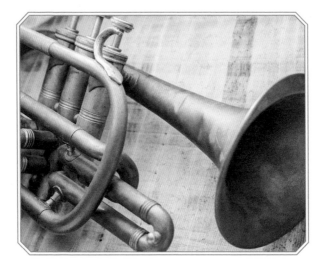

JULY 13–14

What we play is life.

~ LOUIS ARMSTRONG

..

..

..

..

..

..

..

..

JULY 15

THINK ABOUT . . .
Pushing the Edge

In 1492, common wisdom said that if you sailed
past the horizon, you would fall off the edge
of the Earth. What are some of your personal
"1492" moments? The times you were absolutely
sure you could not _____ (learn to drive,
pass a difficult class, finish a half marathon,
give birth). Catch a snapshot of your belief
before *and* after your breakthrough.
For example, "I thought there was no way
I would ever drive in traffic" and "I remember
changing lanes on the freeway with a grin."

• • •

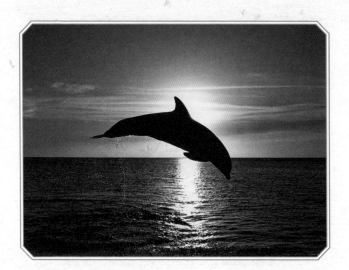

JULY 16–17

Living is a form of not being sure, not knowing what next or how . . . We guess. We may be wrong, but we take leap after leap in the dark.

~ AGNES DE MILLE

..
..
..
..
..
..
..

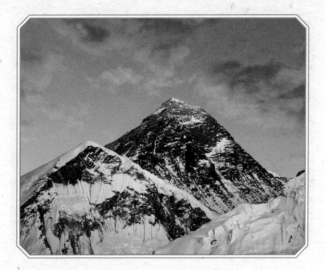

July 18–19

❧

Life is not meant to be easy . . . but take courage:
it can be delightful.

~ George Bernard Shaw

July 20–21

Only those who risk going too far can possibly find out how far one can go.

~ T. S. Eliot

...
...
...
...
...
...
...
...
...
...

JULY 22

ADVENTURE TIP
Surprise and Delight

Buy a pack of sticky notes and write yourself
inspiring messages on as many as you like—
for example, "You are doing good work in the
world" and "You are beautiful!" Think of the
words that would brighten *your* day. Now leave
the notes around your town, office building,
or school. (This is extra fun to do with a
"partner in delight.") Stick the notes on doors,
above a water fountain, inside a book.
You won't know how or by whom they are
received, but the joy of sharing the love will
keep you glowing for days.

• • •

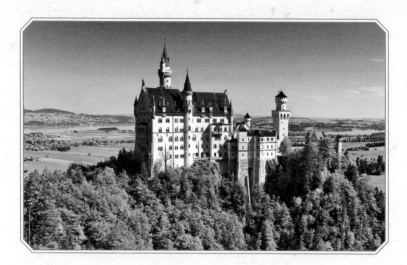

JULY 23–24

Life itself is the most wonderful fairy tale.
~ HANS CHRISTIAN ANDERSEN

..

..

..

..

..

..

..

..

JULY 25–26

There are only two ways to live your life.
One is as though nothing is a miracle.
The other is as though everything were a miracle.

~ ALBERT EINSTEIN

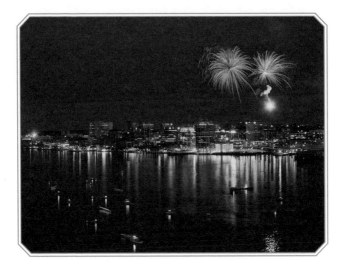

July 27–28

*Stuff your eyes with wonder, live as if
you'd drop dead in ten seconds. See the world.
It's more fantastic than any dream made
or paid for in factories.*

~ Ray Bradbury

..
..
..
..
..
..

JULY 29

ADVENTURE TIP
Radically Random

Find a coin. Now go to a place you have always
wanted to explore: a colorful neighborhood,
a charming main street in another town, a new
park. When you come to a corner, a crossroads,
a choice of any kind, flip your coin. Directions
for both heads and tails—go right/go left—
are whatever you decide *ahead of time*. The very act
of leaving choice to chance is exciting,
and you are guaranteed to have an out-of-
the-ordinary experience.

• • •

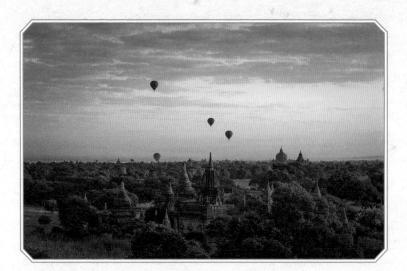

JULY 30–31

Adventure is worthwhile in itself.

~ AMELIA EARHART

...
...
...
...
...
...
...
...

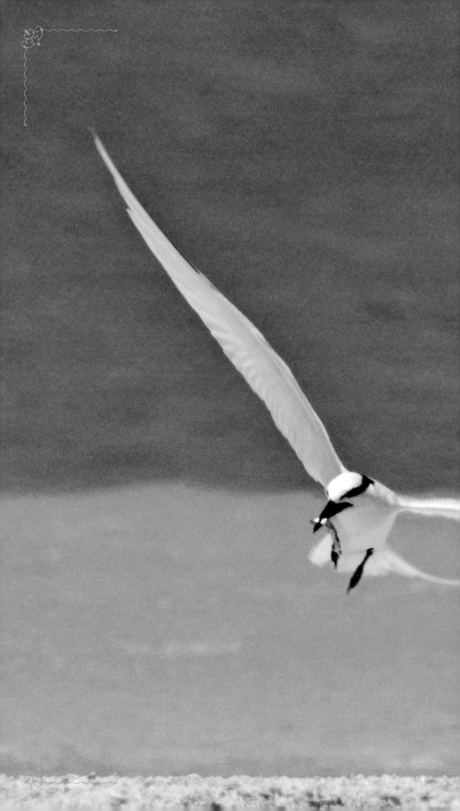

AUGUST

Freedom

AUGUST 1

FREEDOM TIP
Let Loose

Rocking out to your favorite dance music
is a surefire way to feel lighter and freer.
Relive your best bust-a-move moments—
dancing with your granddad at a family reunion,
twirling around your kitchen, or running
at sunset while listening to the perfect playlist.
Let the energy of your memories inspire you
to turn on a favorite tune right now
and express yourself without inhibition.
Don't put this one off!

. . .

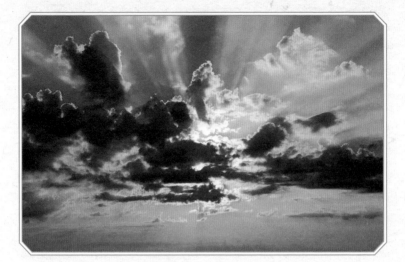

AUGUST 2–3

Lock up your libraries if you like,
but there is no gate, no lock, no bolt,
that you can set upon the freedom of my mind.

~ VIRGINIA WOOLF

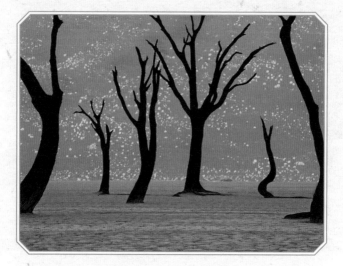

AUGUST 4–5

Life without liberty is like the body without spirit.

~ KAHLIL GIBRAN

*I know but one freedom and that
is the freedom of the mind.*

~ ANTOINE DE SAINT-EXUPÉRY

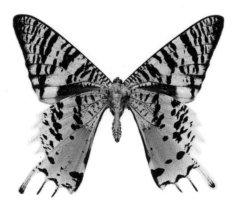

AUGUST 8

THINK ABOUT . . .
Leaping

What are five "leaps" you've made toward greater
freedom and new horizons? It doesn't matter
if the risk turned out in your favor—maybe you
took the job and hated it or moved to the
new country and felt homesick. What matters
is paying attention to where and why you leaped
in the first place. You may discover something
fascinating about your pattern of risk taking
that will be useful for your future.

• • •

AUGUST 9–10

Letting go gives us freedom, and freedom
is the only condition for happiness.
If, in our heart, we still cling to anything—
anger, anxiety, or possessions—we cannot be free.

~ THICH NHAT HANH

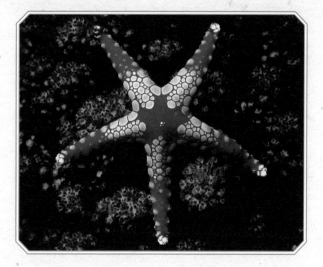

AUGUST 11–12

We do not need magic to change the world,
we carry all the power we need
inside ourselves already: we have
the power to imagine better.

~ J. K. ROWLING

...
...
...
...
...
...

August 13–14

It is the ability to choose which makes us human.
~ Madeleine L'Engle

..
..
..
..
..
..
..
..

AUGUST 15

TRY THIS
Choose Scrumptious

We want to let go of what burdens us:
stale judgments, useless worries, old stories
of coulda, shoulda, woulda. But let's face it:
It's not easy. Today, try a new way of letting go
by choosing scrumptious. Jot down five things
you would love to stop thinking about.
Then, next to each one, write down
a refreshing counterpoint: a soothing breath,
the scarlet flash of hummingbirds at your
feeder, gratitude for a long friendship.
Offer your mind a pleasurable alternative
and see if it's easier to abandon the baggage.

• • •

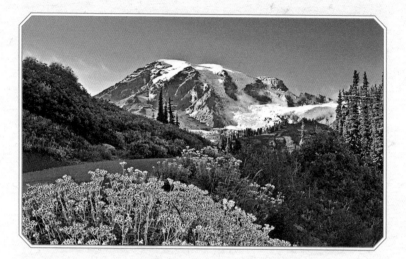

AUGUST 16–17

The real happiness of life is to enjoy the present,
without any anxious dependence upon the future.
~ LUCIUS ANNAEUS SENECA

..

..

..

..

..

..

..

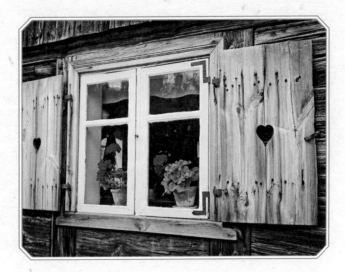

AUGUST 18–19

Perhaps loving something
is the only starting place there is
for making your life your own.

~ ALICE KOLLER

..

..

..

..

..

..

..

AUGUST 20–21

If you obey all the rules,
you miss all the fun.

~ KATHARINE HEPBURN

...
...
...
...
...
...
...
...
...

AUGUST 22

THINK ABOUT . . .
The Freedom to Say Yes . . . and No

How often do you say yes when you mean no,
or no when you want to jump up and down
saying yes? Honoring your preferences
and boundaries is essential to shaping and
directing your life. Think back on the last
month or so: When did you say yes instead
of no? What brought you to those choices?
No blame, just use this opportunity
to reflect on the possibility of choosing
differently in the future.

• • •

...

...

...

...

...

...

...

...

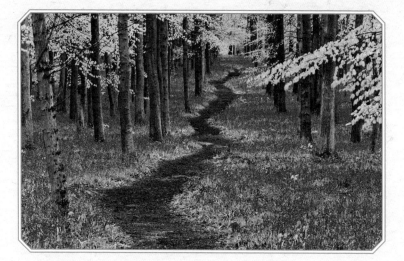

August 23–24

I am still in the process of growing up,
but I will make no progress
if I lose any of myself along the way.

~ Madeleine L'Engle

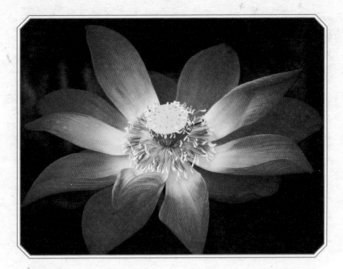

AUGUST 25–26

Those who are free of resentful thoughts
surely find peace.

~ BUDDHA

..
..
..
..
..
..
..

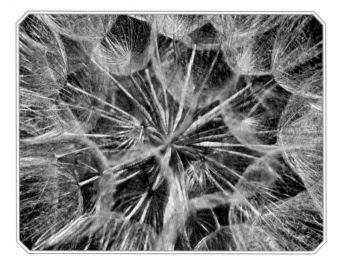

AUGUST 27–28

The power of imagination makes us infinite.

~ JOHN MUIR

AUGUST 29

FREEDOM TIP
Indulge Your Inner Child

Young children are the embodiment of freedom,
unconstrained by social mores of what's cool or
correct. Where and when were you freest in your
younger days that you could re-create now?
Bicycling in the country, playing a Scrabble
marathon, reading a fantasy novel, swimming?
Recall your simple pleasures and then
give yourself one today.

• • •

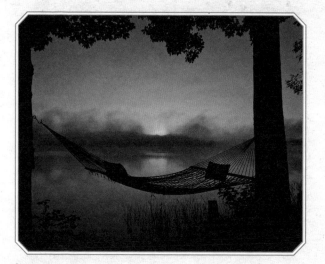

AUGUST 30–31

*If you can spend a perfectly useless afternoon
in a perfectly useless manner, you have learned
how to live.*

~ LIN YUTANG

September

Purpose

SEPTEMBER 1

PURPOSE TIP
Acknowledge Your Accomplishments

Consider that you are already living your
purpose magnificently and today is the day
you celebrate. Close your eyes and see yourself
surrounded by everyone who loves you:
anyone who has helped you, taught you,
and supported you. Breathe in their love,
relish being recognized, and accept
their congratulations for the successful life
you are living. Jot down a few compliments
to turn to when in need of inspiration.

• • •

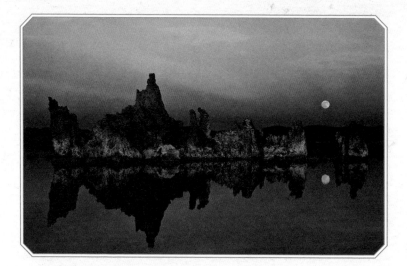

SEPTEMBER 2–3

*The purpose of life is a life
of purpose.*

~ ROBERT BYRNE

..
..
..
..
..
..
..
..

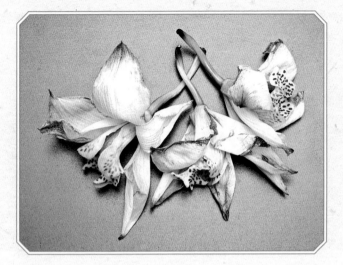

SEPTEMBER 4–5

*Failure is only an opportunity
to begin again more intelligently.*

~ HENRY FORD

SEPTEMBER 6–7

Nothing is a waste of time if
you use the experience wisely.
~ AUGUSTE RODIN

...

...

...

...

...

...

...

SEPTEMBER 8

THINK ABOUT . . .
Your Hidden Talents

How has a failure or setback helped you
develop a talent? Perhaps losing a job
sent you back to school, where you discovered
a passion for art. Or an illness helped you
learn to stand up for your needs. Reflect on
and appreciate the talents that you've mined
from life's challenges.

• • •

SEPTEMBER 9–10

Every noble work is at first impossible.
~ THOMAS CARLYLE

..
..
..
..
..
..
..
..

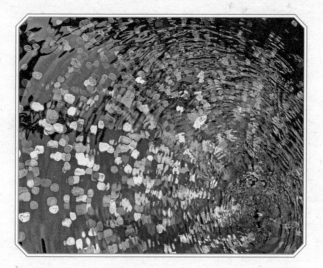

SEPTEMBER 11–12

Great minds have purposes;
others have wishes.

~ WASHINGTON IRVING

..
..
..
..
..
..
..
..

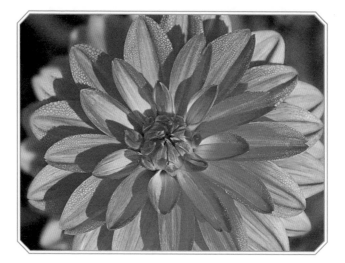

September 13–14

You have to participate relentlessly in
the manifestation of your own blessings.

~ Elizabeth Gilbert

SEPTEMBER 15

PURPOSE TIP
Do It for You

Living with purpose means that neither praise
nor blame controls you. Therefore, the things
you do only for praise or give up on when the
going gets tough are probably out of alignment
with your true values. As you go through
your day, be aware of what things you would
keep doing, no matter what. Write a few of them
down to appreciate what truly matters to you.

• • •

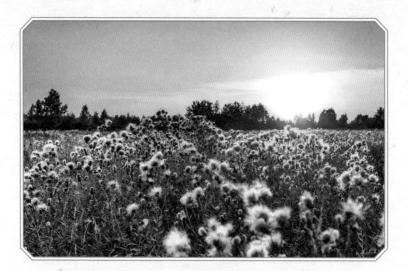

SEPTEMBER 16–17

Although the world is full of suffering,
it is also full of overcoming it.
~ HELEN KELLER

SEPTEMBER 18–19

Don't find fault, find a remedy.

~ HENRY FORD

..
..
..
..
..
..
..

SEPTEMBER 20

TRY THIS

See Yourself Through Another's Eyes

Interview five (yes, five) people you trust—
by email, by phone, or in person. Ask them:
What do you count on me for? Where and when
do I seem most passionate? What do I bring
to your life? Doing this may make you squirm
and blush, but it will reveal gifts you might not
otherwise see. Appreciate yourself reflected
in the eyes of those who know you best.

. . .

SEPTEMBER 21–22

The only source of knowledge is experience.

~ ALBERT EINSTEIN

..
..
..
..
..
..
..
..

SEPTEMBER 23–24

Inspiration usually comes during work,
rather than before it.
~ MADELEINE L'ENGLE

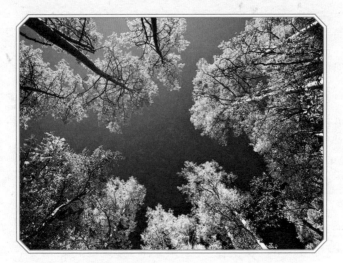

SEPTEMBER 25–26

Learn to get in touch with the silence within yourself
and know that everything in this life has a purpose.
~ ELISABETH KÜBLER-ROSS

..
..
..
..
..
..
..
..

SEPTEMBER 27

THINK ABOUT . . .
The Perks of Living Purposefully

What do you get out of living in alignment
with your values? Think back to the last time
you said no because the project in question
wasn't a fit for you, or when you worked hard
on a project simply because you were passionate.
What were the benefits to making that hard
decision or creating that project? Describe how
you felt—proud, energized, at peace?
Making this list will remind you that living
by what you treasure is well worth the effort.

• • •

SEPTEMBER 28

PURPOSE TIP
Play the Long Game

Living by your values is a time-honored way
of finding greater purpose. But how do you
remember your values when you're under stress
or when times are tough? Ask yourself these
two questions: *Who do I want to be right now?*
What do I want to be remembered for?

The first question will remind you of your
best self—the one we can all easily forget
when we're rushed, tired, or angry. The second
question will point you toward the future:
After the stressful day is over, what do you want
others to remember about their interactions
with you? Play with these two questions
and see if they leave you feeling more fulfilled.

• • •

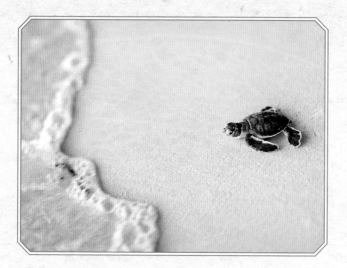

September 29–30

*Always bear in mind that your own resolution
to succeed is more important than any other.*

~ ABRAHAM LINCOLN

...

...

...

...

...

...

OCTOBER

Fulfillment

OCTOBER 1

FULFILLMENT TIP
Set the Standard

If you don't declare what fulfills you, you will
never be fulfilled. This applies to all issues,
large and small: travel, work, weeding the gar-
den. If your satisfaction depends on other
people's opinions or values, you'll never be
at peace. Consider what's right for you. This
doesn't mean avoiding big goals; instead, focus
on the goals that depend only on you. Take small
steps to achieve them—starting now!

• • •

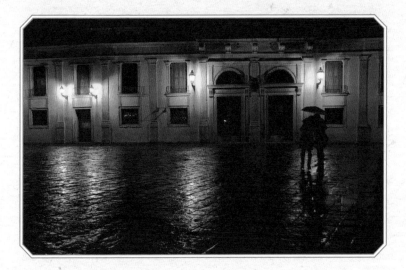

OCTOBER 2–3

The grand essentials of happiness are:
something to do, something to love,
and something to hope for.
~ ALEXANDER CHALMERS

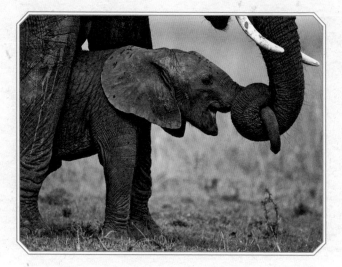

OCTOBER 4–5

*You can never really live anyone else's life,
not even your child's. The influence
you exert is through your own life,
and what you've become yourself.*

~ ELEANOR ROOSEVELT

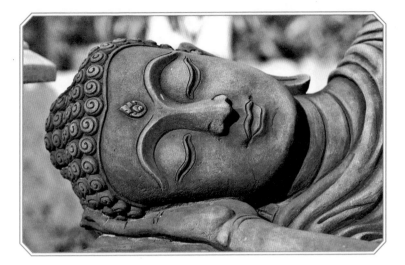

OCTOBER 6–7

*Health is the finest possession. Contentment is the
ultimate wealth. Trustworthy people are the best
relatives. Unbinding is the supreme ease.*

~ BUDDHA

OCTOBER 8

※

TRY THIS
Embrace the New Normal

Fulfillment can be elusive when you keep
waiting for your life to get back to "normal."
As in, "I'll get back to eating healthy
when things settle down," or "I'll tackle
that project once everything else is in order."
Yet often, "normal" never arrives—or at least,
not for very long. Ask yourself, What action
would I take on one of my goals if my life
was "normal" right now? Write down
the possibilities. Be open to surprise.

• • •

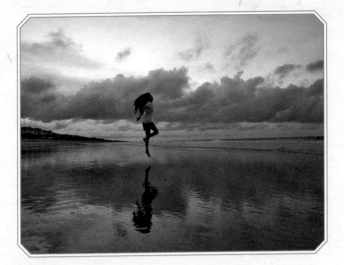

OCTOBER 9–10

*When we cannot find contentment in ourselves,
it is useless to seek it elsewhere.*

~ FRANÇOIS DE LA ROCHEFOUCAULD

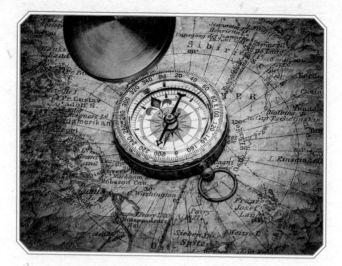

OCTOBER 11–12

You will never be happy if you continue to search for what happiness consists of. You will never live if you are looking for the meaning of life.

~ ALBERT CAMUS

...
...
...
...
...
...
...

October 13–14

Anything you're good at contributes to happiness.
~ Bertrand Russell

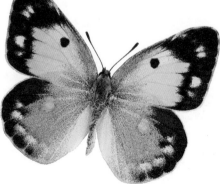

OCTOBER 15

THINK ABOUT . . .
Corking the Drain

Contentment can leak away through
unfinished projects, unresolved conversations,
and niggling habits. But plugging the drain
of your well-being isn't as difficult as you may
imagine, and the payoff can be astonishing.
List ten of your biggest "contentment drains."
Be gently honest about what's depleting
your satisfaction, and name one small step
you will take to eliminate each concern.
Do one right now.

. . .

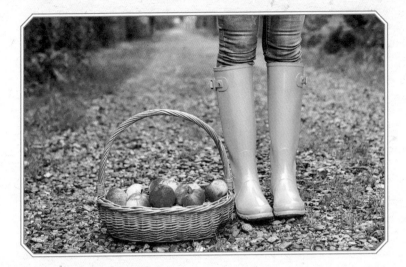

OCTOBER 16–17

If you always do what interests you,
at least one person will be pleased.

~ KATHARINE HEPBURN

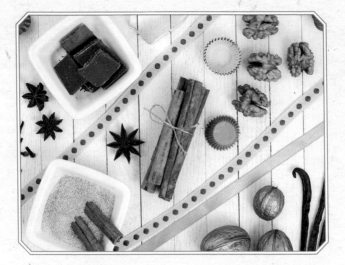

OCTOBER 18–19

One of the secrets of a happy life
is continuous small treats.

~ IRIS MURDOCH

OCTOBER 20–21

Human happiness and human satisfaction
must ultimately come from within oneself.

~ DALAI LAMA

..

..

..

..

..

..

..

..

..

..

OCTOBER 22

FULFILLMENT TIP
Engage Your Senses

You can increase your happiness
when you pause to savor good moments using
all of your senses. Focus on smelling, tasting,
touching, and luxuriating in what's delightful.
Linger in the warmth of a hug. Notice the
texture of the first bite of a crisp apple.
Bask in the adoration in your pet's eyes.
For 30 seconds, relish your pleasure.
Every time you do this, you are literally
wiring your brain for greater joy.

• • •

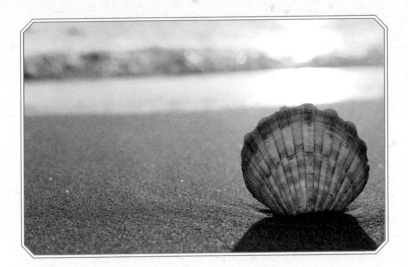

OCTOBER 23–24

*One cannot collect all the beautiful shells
on the beach. One can collect only a few,
and they are more beautiful if they are few.*
~ ANNE MORROW LINDBERGH

..
..
..
..
..
..
..

OCTOBER 25–26

Now and then it's good to pause in our pursuit
of happiness and just be happy.
~ GUILLAUME APOLLINAIRE

...
...
...
...
...
...
...

OCTOBER 27–28

*People tend to think that happiness
is a stroke of luck, something that will descend
like fine weather if you're fortunate. But happiness
is the result of personal effort. You fight for it,
strive for it, insist upon it, and sometimes even
travel around the world looking for it.*

~ ELIZABETH GILBERT

...
...
...
...

OCTOBER 29

TRY THIS
Meet Your Future Wise Self

Imagine yourself 20 or more years from now.
During those intervening years you have
grown tremendously—you've worked hard
to learn and change, pursuing a path
that gives you great pride.

Close your eyes and envision this future self.
What do you look like? How do you spend
your days? Write down what advice, wisdom,
and clarity the grown-up you might offer
the younger you today. Post this note
where you can see it often.

• • •

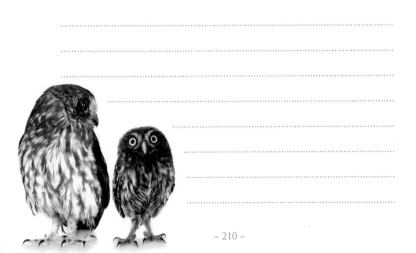

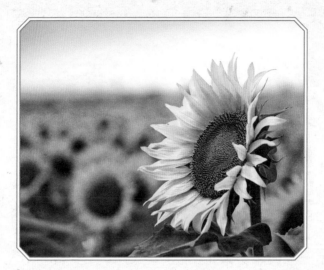

OCTOBER 30–31

*Don't wait around for other people
to be happy for you. Any happiness you get,
you've got to make yourself.*

~ ALICE WALKER

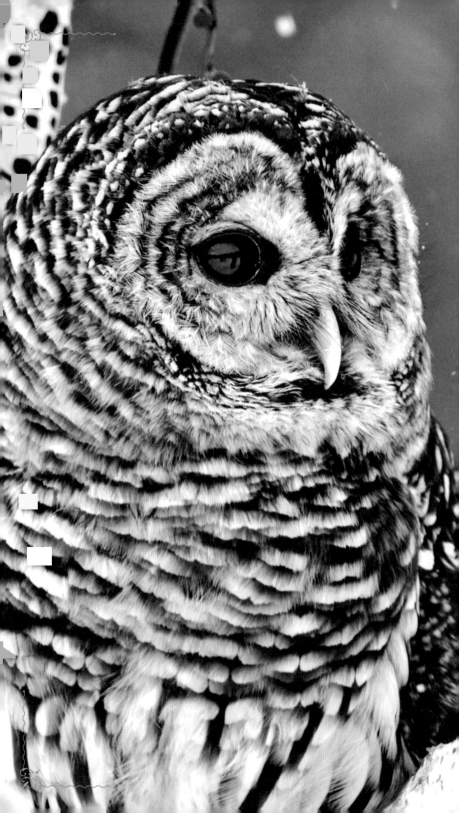

November

Wisdom

NOVEMBER 1

WISDOM TIP
Decide With Confidence

If self-trust is the precursor to living your
"one wild and precious life" (as the poet
Mary Oliver put it), then trying to do it right
is the precursor to living an empty life—a life
that is not yours. Foster self-trust at decision
moments by asking, "What do I know?"
Give your inner voice a chance *before* you
look for the "right" way or ask a friend.
Forget about what you think you *should* do
and consider what's important to you.
Therein lies your most precious wisdom.

• • •

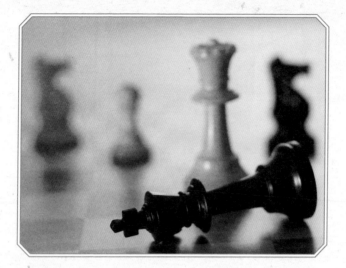

NOVEMBER 2–3

*The most common way people give up their power
is by thinking they don't have any.*

~ ALICE WALKER

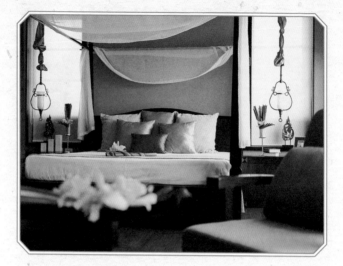

November 4–5

*Self-pity in its early stages is as snug
as a feather mattress. Only when it hardens
does it becomes uncomfortable.*

~ MAYA ANGELOU

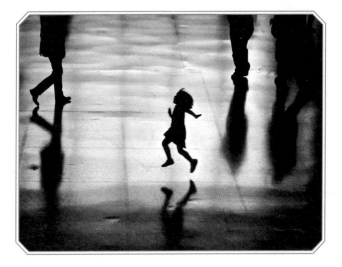

November 6–7

The human race has one really effective weapon,
and that is laughter.

~ Mark Twain

...
...
...
...
...
...
...
...

November 8

THINK ABOUT . . .
Big Dreamers

What people do you admire for making
their dreams a reality? Begin a list.
Include people you know (your aunt Sarah,
your seventh grade English teacher) and icons
you admire (Rosa Parks, Eleanor Roosevelt).
Next to each name, note one way the person
realized her or his goals. Don't worry
about the facts; what matters is what
inspires you. Now write your own
dream-to-reality action plan.

• • •

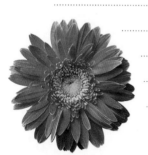

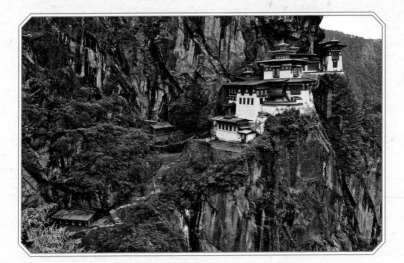

NOVEMBER 9–10

It is good to have an end to journey toward;
but it is the journey that matters, in the end.

~ URSULA K. LE GUIN

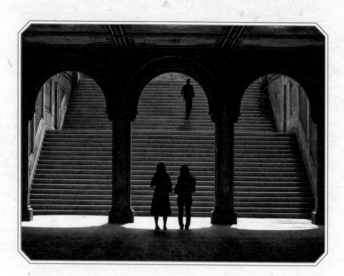

November 11–12

*Look on every exit as being
an entrance somewhere else.*

~ Tom Stoppard

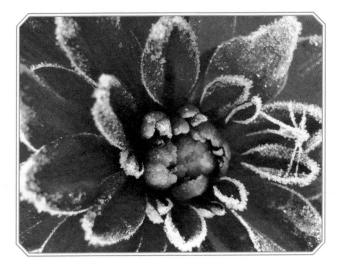

NOVEMBER 13–14

Things are always in transition.
Nothing ever sums itself up
the way we dream about.

~ PEMA CHÖDRÖN

...
...
...
...
...
...
...

NOVEMBER 15

TRY THIS
Share Your Miracle Story

It's commonly noted that change is difficult,
that we resist it, and that it only happens
in small increments. That's often true.
And yet we all have a story or two of a change
that was easy, even miraculous. "I suddenly
started loving to exercise and now rarely miss
a day," or "One day, I knew it was time to quit
that job—and boom! I did." What is your story
of seemingly miraculous change? Describe
the "aha" moment and remember how it felt
to be free. If you can't think of one, imagine
the miracle change you want right now.
Invite it through your imagination.

• • •

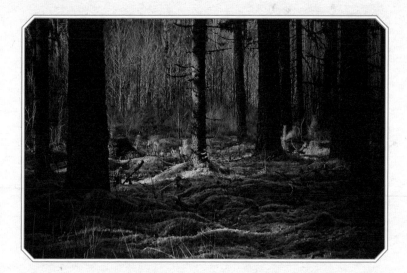

NOVEMBER 16–17

Sleep is the best meditation.

~ BUDDHA

..
..
..
..
..
..
..
..

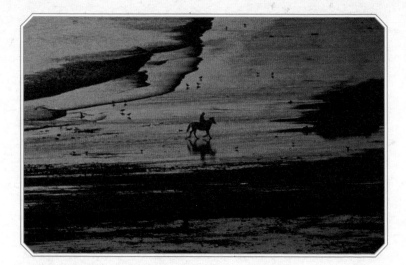

November 18–19

Our perfect companions never
have fewer than four feet.

~ COLETTE

..
..
..
..
..
..
..

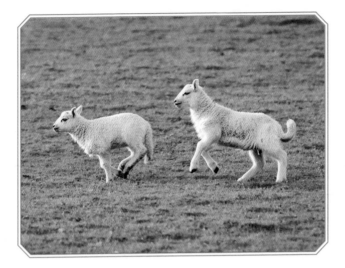

November 20–21

Everyone chases after happiness,
not noticing happiness is right at their heels.
~ Bertolt Brecht

November 22

WISDOM TIP
Make Lemonade

Your unfulfilled desires can resurface
in the form of resentment and frustration.
Is it possible you desire more rest or need to put
more energy into your own unrealized dream?
Are you jealous of a friend's lovely home?
Is it time to de-clutter, eat on your good china,
or paint the living room? Summon the courage
to peer at your envy. You may find vital insights
into what you need more of in your life.

• • •

NOVEMBER 23–24

*The body is a sacred garment. It's your first
and last garment; it is what you enter life in
and what you depart life with,
and it should be treated with honor.*

~ MARTHA GRAHAM

..
..
..
..
..
..

NOVEMBER 25–26

It's easy to be heavy; it is hard to be light.

~ G. K. CHESTERTON

..
..
..
..
..
..
..
..

NOVEMBER 27

❧

THINK ABOUT . . .
Gratitude Garb

Compose a gratitude list about your body
by naming what you've been privileged to enjoy,
experience, and create because of it. Thank your
hands for all they have allowed you to touch,
your eyes for the wonders you've seen,
and your heart for the enormous range
of emotions you've felt. Include the parts
of your body you tend to judge harshly or that
don't always work the way you wish they did.
Dress yourself in gratitude.

• • •

..
..
..
..
..
..
..
..

NOVEMBER 28

WISDOM TIP
Celebrate Your Brilliance

Everyone is wise in his or her own way;
there is no one-size-fits-all definition
of wisdom. Consider your particular style:
Are you great at sensing whether someone
is trustworthy? Do you always know exactly
what gift to give or book to recommend?
Maybe your wisdom comes in sifting through
tons of information and making a reasoned
decision or in helping others resolve conflicts.
Today, observe and honor your unique kind
of intelligence. In doing so, you'll naturally
value it—and yourself—much more.

. . .

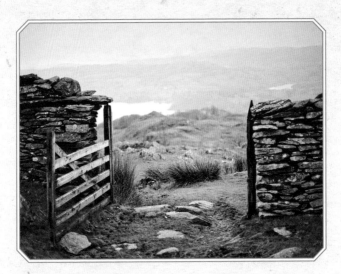

November 29–30

Happiness often sneaks in through a door
you didn't know you left open.

~ John Barrymore

...
...
...
...
...
...
...
...

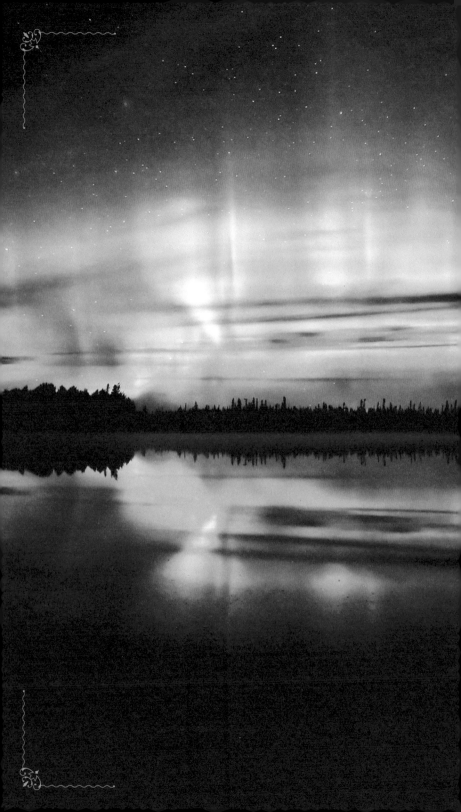

DECEMBER

❦

Faith

DECEMBER 1

FAITH TIP
Become Your Biggest Champion

Faith flourishes when you make a conscious
decision to resist fear and take charge of your
own life. When you declare, "I trust myself
to handle what life brings. I trust myself
to learn as I go," it becomes easier to take risks
and handle disappointments and loss. On the
other hand, judging yourself too harshly and
expecting perfection stifles growth. Be your own
biggest champion by taking full responsibility
for your choices and forgiving yourself when
you make a mistake. You might find that
your faith expands, too.

. . .

...

...

...

...

...

...

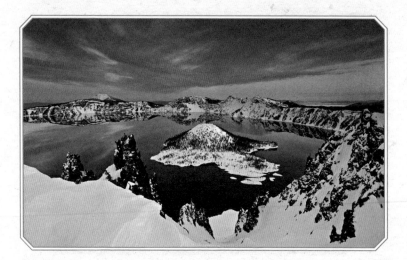

DECEMBER 2–3

The most beautiful thing we can experience
is the mysterious. It is the source
of all true art and science.

~ ALBERT EINSTEIN

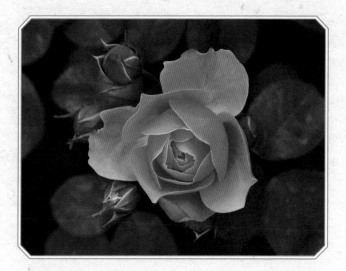

DECEMBER 4–5

Believe that your life is worth living,
and your belief will help you create the fact.
~ WILLIAM JAMES

DECEMBER 6

TRY THIS
Trust in Your Experiences

Faith and trust are forged in moments of
experience: sometimes beautiful, like falling in
love, and sometimes heartbreaking, like losing
someone who matters. These experiences help
you touch something that builds your faith—
in others, in yourself, and in life itself.
What experiences have helped you grow
your faith? What did that maturing faith bring?
It may help to think back to high and
low moments in your past.

• • •

DECEMBER 7

TRY THIS
Love Your Doubts

Faith needs doubt to grow strong.
Blind faith, or simply believing what you
are told, is plain dangerous. When has
exploring doubts and asking hard questions
developed your commitment and confidence?
Is there a situation in your life right now
where testing your assumptions could
be empowering?

• • •

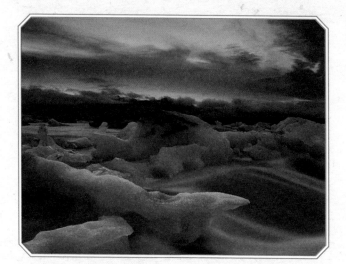

DECEMBER 8–9

You must not abandon the ship in a storm
because you cannot control the winds . . .
What you cannot turn to good, you must
at least make as little bad as you can.

~ THOMAS MORE

..
..
..
..
..
..

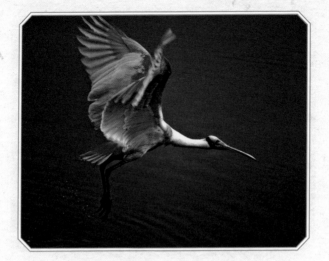

DECEMBER 10–11

*Faith is the bird that feels the light and sings
when the dawn is still and dark.*

~ RABINDRANATH TAGORE

DECEMBER 12

FAITH TIP
Write a Better Story

When you're feeling stuck—say about making
exercise a regular part of your life—try this:
Write a better story. First jot down what
you have been doing in the third person.
For example, "She thinks about going
to the gym almost every day. She checks
her email instead." Put this story aside
for one day. Next, write the better story—
the story you truly want to be living—also in
the third person. Read it first thing every
morning for a week. Notice what happens.

• • •

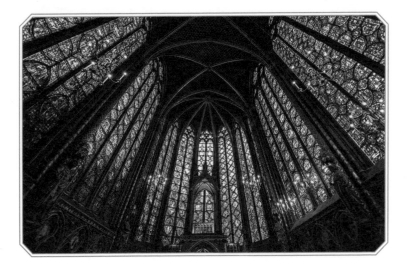

DECEMBER 13–14

Faith is knowledge within the heart,
beyond the reach of proof.

~ KAHLIL GIBRAN

...
...
...
...
...
...
...
...

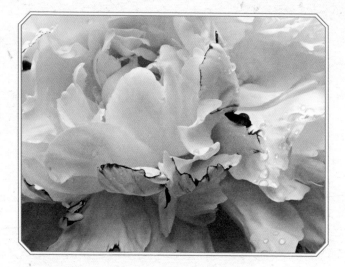

December 15–16

*Gratitude is the fairest blossom
from which springs the soul.*

~ Henry Ward Beecher

..
..
..
..
..
..
..
..

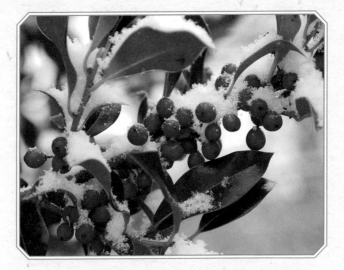

DECEMBER 17–18

Reason is our soul's left hand, faith her right.
By these we reach divinity.

~ JOHN DONNE

..
..
..
..
..
..
..

DECEMBER 19

THINK ABOUT . . .
Faith in Your Gifts

Create a list of your most overlooked
or downplayed accomplishments.
You may need to ask family and friends.
Self-acknowledgment leads to greater
confidence but only if you take the time
to lovingly witness your own story.
Write your song of praise.

• • •

DECEMBER 20

TRY THIS
Share Your Faith

Consider what you have faith in: the power
of healthy food to heal, the power of love
to inspire change, your ability to listen
compassionately. Next, brainstorm a simple way
to share your faith: teach a cooking class,
volunteer at a senior care center, invite a friend
on a weekly stroll, mentor a struggling student.
Do this in honor of all that you believe.

• • •

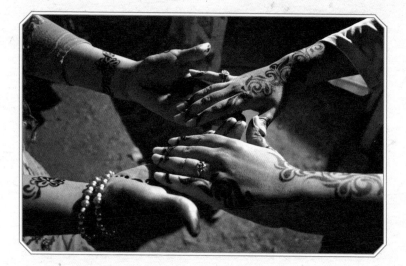

December 21–22

When we do the best that we can,
we never know what miracle is wrought
in our life, or the life of another.
~ Helen Keller

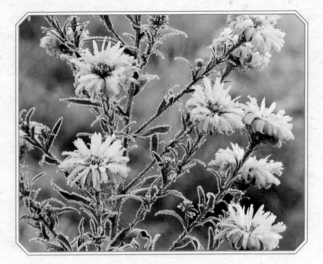

DECEMBER 23–24

Faith is not something to grasp;
it is a state to grow into.

~ MAHATMA GANDHI

DECEMBER 25

FAITH TIP
Accept Support

Notice what you are sitting or lying against
right now. Relax into the support. Take a full
breath and on the exhale, release any tension
you may be holding. Notice the present truth:
You are supported—literally by the chair,
for instance, but also by your friends,
your family, and most of all, your own
hard-earned wisdom. Relax into the support
that is always there for you and savor
the feeling of being held.

• • •

DECEMBER 26

TRY THIS
A Year in Review

Read over your entries in this journal,
jotting down key insights from this time
of learning. Take stock of where your inner
wisdom expanded the most, along with your
courage and your ability to realize your dreams.
Create a map of celebration and remembrance
to guide you into the new year.

• • •

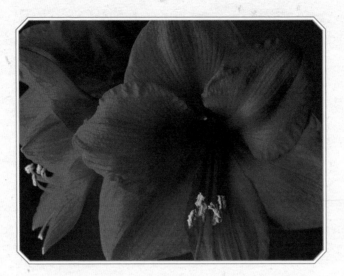

DECEMBER 27–28

*Anything that is of value in life
only multiplies when it is given.*

~ DEEPAK CHOPRA

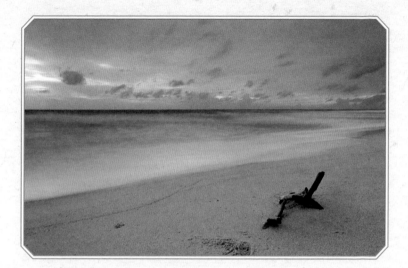

DECEMBER 29–30

*The only faith that wears well and holds its color
in all weathers is that which is woven of conviction
and set with the sharp mordant of experience.*

~ JAMES RUSSELL LOWELL

..

..

..

..

..

..

DECEMBER 31

THINK ABOUT . . .
Self-Care Minimums

Skip making resolutions for the new year
and instead make a list of what you need to stay
healthy and in touch with yourself. Not because
you will be able to achieve everything,
but because naming these needs will help you
recognize when you are—and aren't—getting
the minimum you need to be good to yourself.
Those self-care essentials might include time
to write in your journal, eight hours of sleep,
two weekend getaways with girlfriends a year—
whatever matters to you. Sometimes we think
we need to change our entire lives when
maybe all we need is a half hour alone
with a journal and a pen. Please take
good care of your precious self.

. . .

ACKNOWLEDGMENTS

Thanks to the generous and smart Janet Goldstein, the patient
and lovely Hilary Black, and the kind and clever Anne Smyth;
to the brilliant art team, Melissa Farris, Nancy Marion, and
Katie Olsen; to all the incredible thinkers and teachers whose
quotes bring wisdom to this book; and especially to the
photographers whose images illuminate these pages,
helping us love this amazing world and ourselves even more.

ILLUSTRATIONS CREDITS